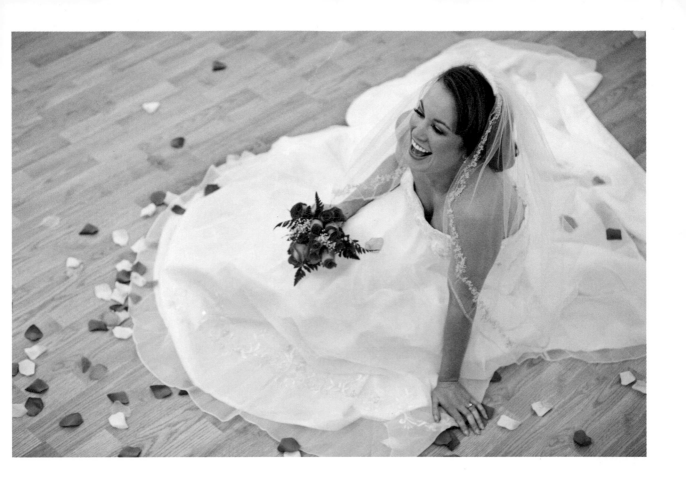

# Digital Wedding Photography Secrets

*Rick Sammon*

Sanjose July.09

**WILEY**

**Wiley Publishing, Inc.**

Digital Wedding Photography Secrets

Published by
Wiley Publishing, Inc.
10475 Crosspoint Boulevard
Indianapolis, IN 46256
www.wiley.com

Copyright © 2009 by Wiley Publishing, Inc., Indianapolis, Indiana

Published simultaneously in Canada

ISBN: 978-0-470-48109-7
Manufactured in the United States of America

10 9 8 7 6 5 4 3 2 1

For general information on our other products and services or to obtain technical support, please contact our Customer Care Department within the U.S. at (800) 762-2974, outside the U.S. at (317) 572-3993 or fax (317) 572-4002.

Wiley also publishes its books in a variety of electronic formats. Some content that appears in print may not be available in electronic books.

Library of Congress Control Number: 2009922577

Cover photograph © istockphoto.com.

# About the Author

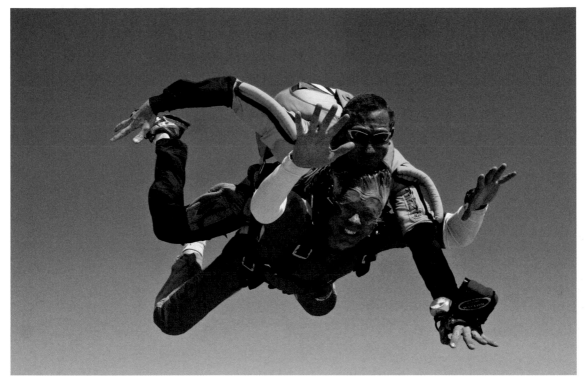

*Rick Sammon (lower tandem jumper), falling to earth at 125 miles per hour, during one of the few times that he was not photographing, writing a book, leading a workshop or giving a seminar.*

## Rick Sammon

Rick Sammon has published 31 books, including his latest three: *Rick Sammon's Secrets to Digital Photography, Face to Face* and *Exploring the Light*—all published in 2008! His book, *Flying Flowers* won the coveted Golden Light Award, and his book *Hide and See Under the Sea* won the Ben Franklin Award.

Rick has photographed in nearly 100 different countries and gives more than two dozen photography workshops and presentations around the world each year. He also hosts five shows on kelbytraining.com and writes for *PCPhoto, Layers* magazine and photo.net.

Nominated for the Photoshop Hall of Fame in 2008, Rick Sammon is considered one of today's top digital-imaging experts. He is well-known for being able to cut through Photoshop "speak" to make it fun, easy and rewarding to work and play in the digital darkroom.

When asked about his photo specialty, Rick says, "My specialty is not specializing."

You can catch Rick at Photoshop World, which he says is a "blast." See www.ricksammon.com for more information.

# Credits

**Acquisitions Editor**
Courtney Allen

**Project Editor**
Jenny Brown

**Technical Editor**
Alan Hess

**Copy Editor**
Jenny Brown

**Editorial Manager**
Robyn Siesky

**Business Manager**
Amy Knies

**Senior Marketing Manager**
Sandy Smith

**Vice President and Executive Group Publisher**
Richard Swadley

**Vice President and Publisher**
Barry Pruett

**Book Designer**
Erik Powers

**Media Development Project Manager**
Laura Moss

**Media Development Assistant Project Manager**
Jenny Swisher

# Acknowledgments

As you saw on the cover, I get credit for writing this book. Sure, I put a ton of work into it, but the truth is I had a lot of help—just like every author. It's the same for all artists. Take Tom Cruise for example. He gets top billing, but he has a slew of people—from make-up artists, lighting directors and set designers to acting coaches and stylists—that make him look good.

So I thought I'd take this opportunity to thank the folks who helped put together this work, as well as those who have helped me along the path to producing this book, which is my 32nd.

The guy who initially signed me up for this book is the same guy who made my Canon Digital Rebel and Basic Lighting DVDs happen: Barry Pruett, Vice President at Wiley. Barry has a quality that every author needs: faith in the author's belief that someone actually wants to hear what (s)he has to say!

Once I was signed up, Courtney Allen, a quite talented Acquisitions Editor at Wiley, took over the project and helped me big time—with everything you see between the front and back covers. Not an easy task…especially considering that the book was produced is just a few months.

More help was on the way! Alan Hess, my technical editor, also added his expertise. Thanks Alan!

I also want to thank Jenny Brown of Brown Ink for her excellent work as Copy Editor and Project Editor, Erik Powers of Creative Powers for his phenomenal job at designing and producing the book, and Mike Trent for his work on the front and back cover design. Thank you all for your eagle eyes and artistic flair – and for patience working with me!

Someone who has been helping me for 58 years also worked on this book. My dad, Robert M. Sammon, Sr., who is 90, actually read each and every word, using his wordsmith skills to improve my words! I could not have done it without you dad.

Two more Sammons get my heartfelt thanks: my wife, Susan, and son, Marco. For years, they both supported my efforts and helped with the photographs. Thanks Susan and Marco for all your help and love.

Julieanne Kost, Adobe Evangelist, gets a big thank you for inspiring me to get into Photoshop in 1999. Addy Roff at Adobe also gets my thanks. Addy has given me the opportunity to share my Photoshop techniques at trade shows around the country.

Some friends at Apple Computers also helped me during the production of this book by getting me up to speed with Aperture 2, the application I use most often to import and edit my photographs. So, more thank you notes go to Don Henderson, Fritz Ogden and Kirk Paulson.

Other friends in the digital-imaging industry who have helped in one way or another include David Leveen of MacSimply and Rickspixelmagic.com, Mike Wong and Craig Keudell of onOne Software, Wes Pitts of *Outdoor Photographer* and *PCPhoto* magazines, Ed Sanchez and Mike Slater of Nik Software, Scott Kelby of *Photoshop User* magazine, and Chris Main of *Layers* magazine.

Rick Booth, Steve Inglima, Peter Tvarkunas, Chuck Westfall and Rudy Winston of Canon USA have been ardent supporters of my work and photography seminars … so have my friends at Canon Professional Service (CPS). My hat is off to these folks, big time! The Canon digital SLRs, lenses and accessories that I use have helped me capture the finest possible pictures for this book.

Kelly Mondora of FJ Westcott is a super friend for getting me the lighting gear I needed to take many of the studio and on-location shots that appear in this book.

Jeff Cable of Lexar hooked me up with memory cards (4GB and 8GB because I shoot RAW files) and card readers, and these were all well-used in taking pictures for this book.

Of course, all my photographer friends who sent me photographs and tips for the "Pros Share Their Shooting Secrets" chapter get a warm thank you. Don't miss a single tip there!

My photo workshop students were, and always are, a tremendous inspiration for me. Many showed me new digital-darkroom techniques, some of which I used in this book. I find an old Zen saying to be true: "The teacher learns from the student."

So thank you one and all. I could not have written this book without you!

*"If you want to sacrifice the admiration of many men*
*for the criticism of one, go ahead, get married"*

*~ Katharine Hepburn*

# Contents

# Introduction

This book was a ton of fun for me to put together, even though I do not specialize as a wedding photographer. If you have read my other books or viewed my online WebTV shows, you know I don't really claim a specialty; I "specialize" in beautiful photography. Yet I am probably best-known for travel photography—mostly for portraits of strangers in strange lands.

That said, I do have some focused experience with wedding photography.

From 1978 to 1980, I was the editor of *Studio Photography* magazine, which was, at the time, the leading magazine for wedding and portrait photographers. A cover of our special wedding issue opens this introduction.

I was also the editor of *PPA Daily*, which was the daily newspaper of the Professional Photographers of America's annual trade show. At the PPA shows, I attended many seminars on wedding and portrait photography.

# Sharing Secrets

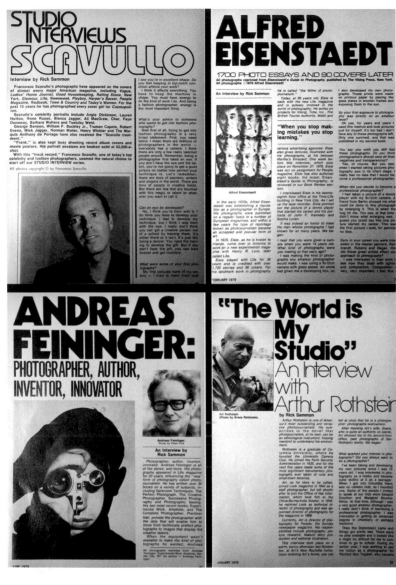

While I was the editor of *Studio Photography*, I had the opportunity to interview many wedding photographers in their studios and learn their secrets …. way back then. Scavullo, Feininger, Rothstein and Eisenstaedt were among my favorite interviews. Here's a look at the opening pages of those interviews. The papers are faded now, but the memories of these luminaries are still sharp in my mind.

During this time, I shot weddings on weekends for studios on Long Island, New York, where I lived. For each event, I tried to apply any new tips and techniques I had gathered from interviews and other sources. And I realized it takes time to figure out how to apply new tricks to specific situations and your personal style.

Now, jumping forward almost 30 years, some of my fellow Canon Explorers of Light (www.usa.canon.com/dlc) are among the top wedding photographers in this country. I have listened intently to their presentations at trade shows while I waited for my own turn to take the stage.

I have been tuned into wedding photography for a long time, and I've stayed current on image-based technology and techniques. I appreciate this opportunity to pass some ideas and techniques on to you.

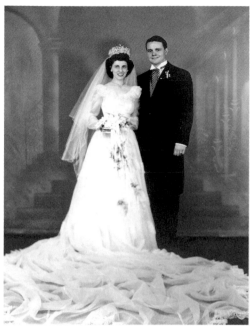 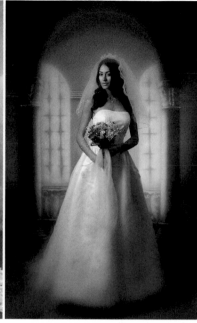

## The Learning Process

During the process of writing this book, I had the opportunity to talk to some of the top wedding photographers in the country, who gladly shared their tips, techniques, secrets and photographs. They did so to help you take better wedding photographs.

And it was a terrific experience for me as a professional, too. Through interacting with industry experts, I also learned a lot and have applied some of their tips to my own work.

See, from a technical standpoint, photography is photography—no matter what occasion or subject. Covering a wedding—and working with a bride and groom to capture their wedding day in a way they love—is a unique specialty, but the technical aspects of photographing people translate to other situations and venues as well.

Perhaps the most fun I had, which turned out to be the best learning experience as well, was a one-day studio shoot I did with a model in New York City. Experimenting with different lighting set-ups, backgrounds and poses gave me a close look at a "day in the life of a studio wedding photographer." You'll see the pictures that came from this shoot later in this book. And hey, if I could get some nice studio shots, having never worked in a studio before, you can too!

Check out these two images. On the right is a photograph taken during this studio session. On the left is a photograph of my parents' wedding (slightly faded), taken in 1947. To my point that photography is photography no matter what the occasion, you can see that many aspects of wedding photography have remained the same over the years. Both of these pictures have good lighting, and they show the subjects in nice poses with a painted background.

So the good news for you is that you can apply the techniques in this book for many years to come.

# Basic People Photography Tips

With all that in mind, I thought it would be fun—and helpful, since I'm sure your photographs sometimes vary from wedding shoots—to compare some of my work with wedding photographs I purchased from istockphoto.com. The intent was to find out if the same technical photography tips apply equally to both images.

Note: My photographs are either on the bottom or right side of each pair.

Indeed, as you'll see, the tips offered in this book definitely apply to people photography in general. For example, using the disequilibrium effect—created by tilting the camera down and to the left or right—makes a photograph look a bit more creative than the standard eye-level shot.

I'll go into this and other tips in more detail later. For now, they are here to help you jump-start your photo learning.

Let's go.

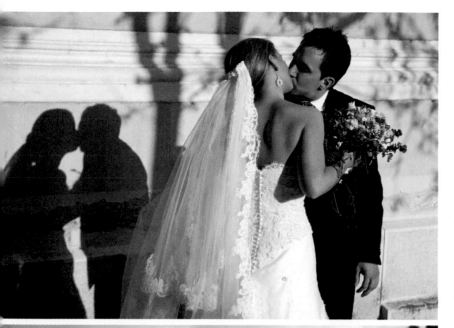

# Place the Subject Off Center

Take a look at these pictures. Even though I am not there beside you, I can guess at your process for looking at these images. You were first drawn to the subjects, and then you began to look around the frame to see what else was happening in the scene.

I know this because both photographs show the technique of placing the subject off center. This compels viewers to look around the frame for other interesting objects.

When you place your subject dead center in the frame, the viewer's eyes get stuck there. It's why professional photographers say, "Dead center is deadly."

## Master Studio-Style Lighting

Some brides and grooms like the photojournalist-type approach for their wedding album. This is basically a style that requires a photographer to shoot what (s)he sees—without any set-up. Other couples prefer the more formal, studio-type approach.

In talking with some married couples who chose the photojournalist style for their wedding, I've heard them say they now have some regrets about not getting studio photographs, too.

As a wedding photographer, you need to be prepared to take studio shots. What's more, you can make extra income by adding studio photographs to your list of services.

You don't need a fancy and expensive studio lighting set up to get nice quality photographs. Westcott (www.fjwestcott.com), for example, sells hot light and strobe light kits—each with three light sources—for under $500 and $800, respectively.

The photograph on the right was taken with a three-light set up that includes a main light, fill light and background/ separation light.

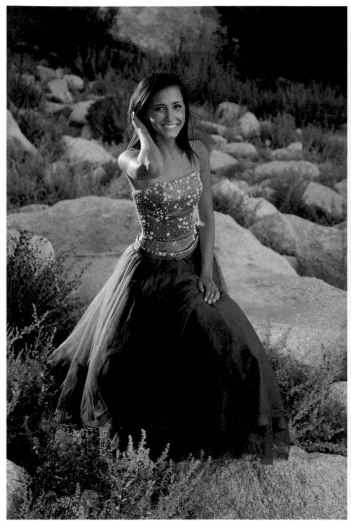 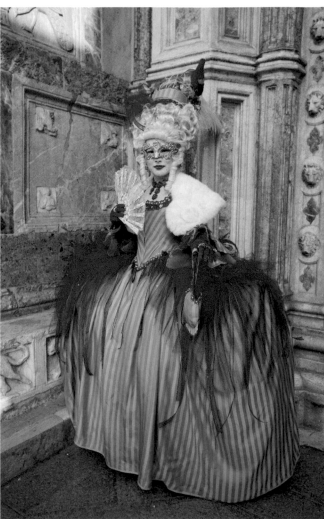

# Watch the Hands

The hands in both of these photographs take up less than 5% of the frame, yet they are important to the overall success of the pictures.

You need to make sure your subject's hands are well-positioned. Don't be shy about providing direction if his or her hands look awkward and need to be placed differently. If left unchecked, gawky hand position can ruin an otherwise terrific photograph.

Yeah, I know this is a short tip—maybe even the shortest one in the book—but it's definitely an important one.

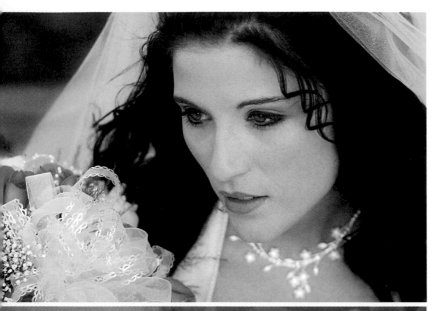

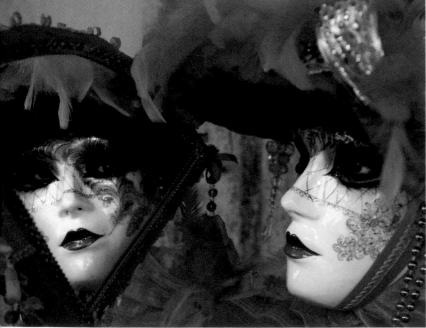

# Work Close for an Intimate Portrait

The closer you are to your subject, the more intimate the portrait becomes. That's why many wedding photographers like to use wide-angle to medium-telephoto zoom lenses and shoot relatively close to subjects when possible.

Working close also lets you identify with and relate better to your subjects. So, get up close and personal.

I have another tip that I'll include here, since I have your attention … and space on the page.

Watch the nose. When you are photographing a subject from the side, be sure that you position his/ her nose so that the cheek acts as a background, as illustrated in the top photograph. Or, position the subject to get a complete profile of the nose, as illustrated in my photograph.

If you don't follow this advice, then the tip of your subject's nose will probably look "funny," sticking out like a lobe from the cheek.

# Expose for the Highlights

Back when I was the editor of *Studio Photography* magazine, I used to shoot slide film. When shooting slides, we had to expose for the highlights. If we did not, the highlights would be overexposed, showing little or no detail. In those cases, the slides were tossed into the out-take pile.

When I shoot digital, I also expose for the highlights … even though in Camera RAW, I can rescue up to one f-stop of overexposed highlights. In fact, this is what I had to do with the istockphoto.com image you see on the left.

Conversely, in the image I shot (on the right), I exposed for the highlights, which saved me time in the digital darkroom.

# Envision the End-Result

Ansel Adams, the most famous landscape photographer of all time, was known for, among other things, envisioning the end result. That is, he considered all—and I mean *all*—the factors that go into taking a picture (including the f-stop, shutter speed, exposure and more) and enhancing it in post processing.

I am big on envisioning the end-result, and I talk a lot about that in my workshops.

When I shot the photograph here (bottom), I envisioned a silhouette even though I could actually see detail in the backlit subject at the time of shooting. This is because our eyes see a dynamic range of about 11 f-stops while cameras see only five or six.

To create the silhouette, I set my camera on the Av mode (automatic) and set my exposure compensation to −1½. Had I used no exposure compensation, some of the detail in the subject would be visible in the image, and the silhouette would be less dramatic.

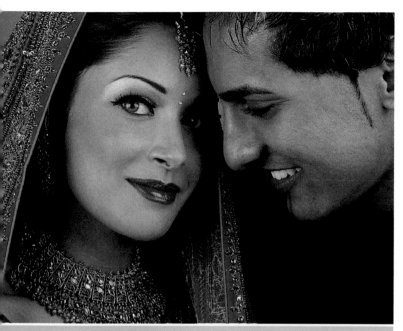

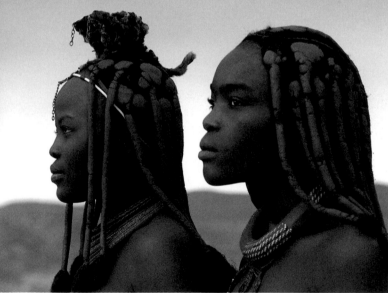

# Make Pictures; Don't Simply Take Pictures

Anyone can take pictures, but not everyone takes the time to *make* them. When we take a picture, we simply point and shoot.

When we make a picture, we carefully arrange subjects in a scene—sometimes moving hair out of the face or posing people in a certain manner. We see the light and use a reflector, diffuser or flash to help control it. We carefully choose our camera angle, lens, exposure mode, and the f-stop and shutter speed combination.

To make my picture of two Himba women in Namibia, I asked them to stand on a log and look off into the distance. As in the above photograph, I positioned them so that their faces were isolated from one another, with no parts overlapping.

Take the time to make pictures in addition to taking candid photographs, and you'll make your clients happy.

 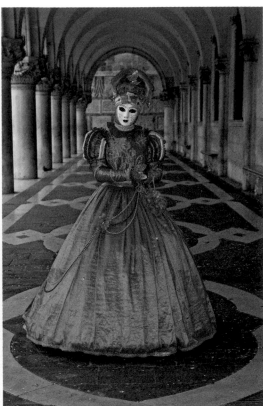

# Always Consider Digital Noise and ISO Setting

Both of the pictures you see here were taken in relatively low light and are clean! "Keeping it clean" is actually one of my main goals when I take a photograph. And by *clean*, I mean the image has very little digital noise. I get clean pictures by shooting at the lowest possible ISO setting for a hand-held shot.

I also shoot with a top-of-the-line digital SLR camera, because top-of-the-line cameras have less noise than entry-level and mid-range digital SLRs.

In situations that require me to use a high ISO, such as shooting in very low light, I sometimes use the noise-reduction feature in my camera. Yet the process of this feature increases the time before I can take another picture. If I can't afford the wait, I reduce the noise in Adobe Camera RAW or Apple Aperture.

When you reduce noise in post processing, reduce the chroma (color) noise first and then luminance noise. In both cases, try not to reduce the noise more than 30%. If you go beyond this, your picture will start to lose sharpness.

Also note that noise shows up more in the shadow areas than in highlight areas.

By the way, in-camera noise-reduction features reduce only chroma noise.

# Use—Don't Overuse—the Disequilibrium Effect

Both of these pictures illustrate what's called the *disequilibrium effect*, which is created when you tilt your camera down and to the left or right.

It's a simple, fun and creative effect. Just don't over use it.

Another tip here: Have fun with this technique!

# The Camera Looks Both Ways

When you photograph a person, you reveal an image of yourself. Your mood, energy and emotions are reflected in your subject's face and eyes. This is what "the camera looks both ways" means.

This is actually my #1 tip when it comes to photographing people—whether your subject is a beautiful bride in her home or church or a magnificent woman in the rainforest. Your disposition matters.

So as a people photographer, keep this expression in mind … and don't get bogged down with camera settings. The technical stuff has to become automatic, so that you can concentrate on getting a great personality portrait that you and your clients will love.

# People Photography Tidbits

This is not a technical photography tip. Rather, it's some interesting thoughts on photographing people that were first published in my previous Wiley book, *Rick Sammon's Digital Photography Secrets*. I share a condensed and modified version with you here because the information offers some perspective on photographing people.

Here goes.

Overhead Lighting: The majority of famous painters "illuminate" their subjects from above and to the left. For whatever reasons, we seem to like that kind of lighting. Here are two pictures that illustrate this lighting technique. Hey, if it works for famous painters and if it works for me, it will work for you!

Open Pupils: Pictures of people with their pupils open wide are typically preferred over those in which pupils are closed down. That's one reason we like pictures of people taken in subdued lighting conditions—in the shade and on cloudy days, when a person's pupils are open wider than they are in bright light and on sunny days.

Color Variation: We see colors differently at different times of the day, depending on our mood and emotional state. Before you make a print, look at it on your monitor at different times of the day to see if you still like your original version. You may want to tweak the color to get the look you like best.

You can learn more facts about people pictures, and why we like them, in one of my favorite books: *Perception and Imaging* by Dr. Richard Zakia. You'll find more info on seeing colors at iLab (http://ilab.usc.edu).

# Make the Time

Here is another non-technical tip. It's a philosophical tip about working as a photographer—well, working in general.

I've told the following story at least a thousand times since 1979. It illustrates the point about wanting to do something and then doing it.

While I was the editor of *Studio Photography*, the cover featuring Jaclyn Smith was my favorite. I thought she was exceptionally beautiful and I liked the photograph. My boss, Rudy Maschke, knew that.

One day he came into my office and asked me to do something. I said, "Mr. Maschke, I'm too busy. I'm sorry I can't do it right now."

He said, "Sammon, who do you think is the most beautiful girl in the world … aside from your wife, of course."

I replied, "Jaclyn Smith."

"Well, Sammon, if Jaclyn called you up right now and asked you to have lunch with her for 20 minutes, would you go?"

"Sure."

He said, "Sammon, get to work."

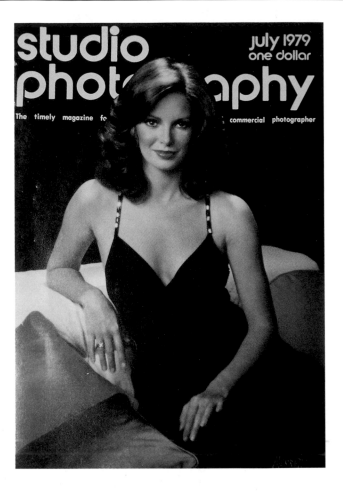

The point of this little story is that if you really want to do something, you'll make the time and you'll do it well.

Keep that story in mind the next time you feel as though you don't have the time to do something.

Here's another thing I learned from Mr. Maschke: When there is not enough time to do something right, there is usually enough time to do it over.

Here is another photo philosophy—well, actually a philosophy for life in general: If you love what you do, you never have to work a day in your life!

Rick Sammon
Croton-on-Hudson
January 2009

*Part 1*

New to digital wedding photography? Want to jumpstart your photo learning? Yeah, well then this chapter is for you. It offers some basic tips—time-proven techniques you can use to get a feel for weddings and to develop an eye for photographing them.

Check out this chapter first, and then move on to more detailed information in the subsequent chapters.

Hey, I know you want to dive into all the cool techniques in this book, but I figure some of you might want to start with some general tips on being a wedding photographer first. Start with the basics on how to go about covering one of the most important days in a couple's life.

These are just a few quick tips, illustrated with istockphoto.com photographs. Let's go!

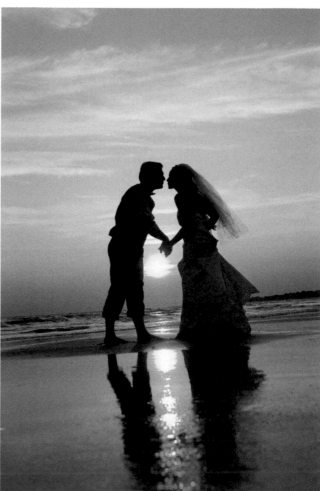

# Know Your Gear

First and foremost, you must know you gear—your cameras, lenses, flashes and so on—inside and out before you show up to shoot a wedding. Since you'll be shooting in a variety of lighting conditions, indoors and out, you must be prepared for everything. No surprises. You also must know your computer system and your digital image-editing programs … very well. You simply can't afford to miss, mess up or lose a shot. It's a wedding!

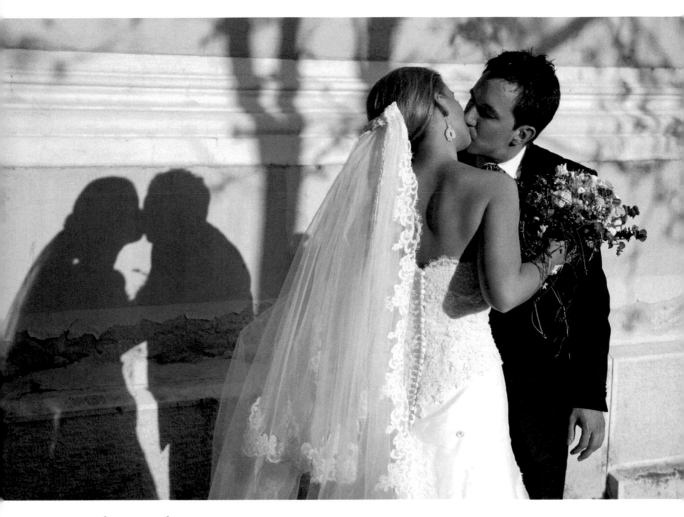

## See the Light

Light is the key component in every picture. No light, no picture. You need to look for shadows and highlights, and know when to expose for each. You need to see the contrast range in a scene, and you need to see the color and direction of the light. Keep an eye on the light, and you'll get pictures that will light up the hearts of your clients.

# Get to Know the Bride

The bride is the centerpiece of a wedding day. In almost every case, she is the one for whom your pictures are most important. Get to know her. Know what she likes and what she dislikes photographically, and be aware of the people and things she holds especially dear on her wedding day. Also get to know her personality, and try to capture it in your photographs. Try to put yourself in her shoes (well, so to speak).

# Scout the Location

Before the big day, spend some time at the wedding site looking for creative angles. Look for potential challenges as well as opportunities. Take some test shots indoors and out and experiment with ISO, white balance, etc. Follow the motto of the Boy Scouts of America: *Be prepared.* Keep in mind that you will not be able to move around so freely during the ceremony. Make a plan.

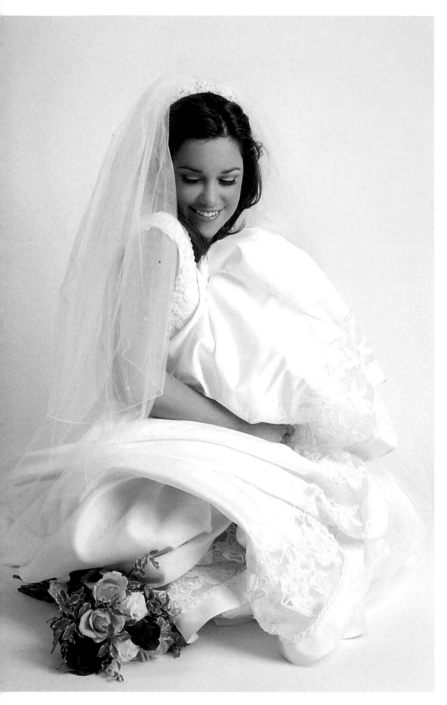

# Point and Shoot in the Studio

When a bride and groom come into your studio, they don't want to see you experimenting with different lighting set-ups. What's more, they don't have the time for your experimentation. Therefore, you must know your lighting set ups completely. When the bride and groom get under your lights, it should become an exercise in point-and-shoot photography.

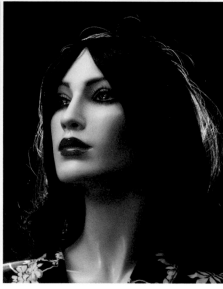

# Practice Studio Lighting with a Dummy

One easy and affordable method for honing your lighting skills is to practice with a mannequin. When working with a dummy, you can place lights in different positions for different effects... and without any threats of charging you overtime.

Here you see, clockwise from the top left, the effect of using:

- one main light

- a main light with a background light (set to half power) and a hair light

- a main light with a background light (set to full power) and a hair light

- a main light and a light behind the subject pointed at the subject

As I mentioned on the previous page, you can't waste time experimenting during a real shoot. If you do, *you* may look like a dummy.

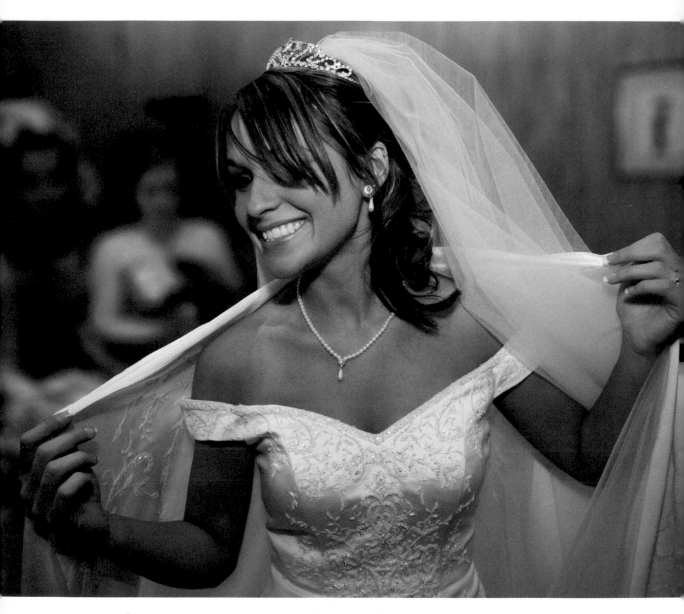

# Cover the Excitement at the Bride's House

For the bride and her friends (and often her parents if they are not too nervous), one of the most enjoyable parts of the wedding day is before the ceremony, when the bride's friends are gathered at her home. Show up on time (not early and not late) and capture all the fun.

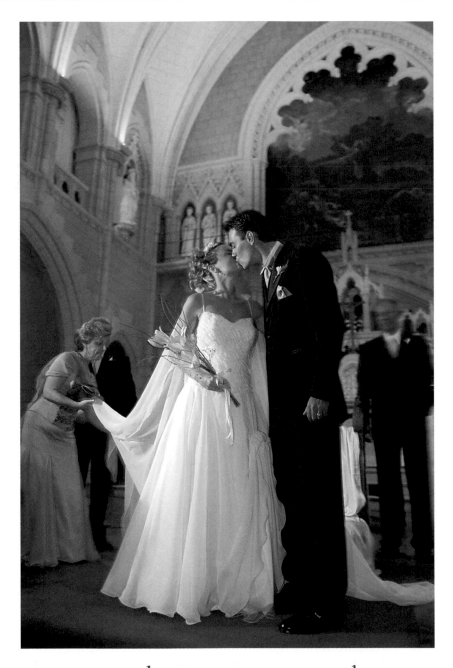

# Don't Miss the Key Ceremony Shots

Sure, be creative and take photographs that perhaps not every wedding photographer on the planet would take. But don't miss those all-important shots, especially the first kiss. Make a shot list with the bride and groom before the big day, so that no one is disappointed during the photo-review session.

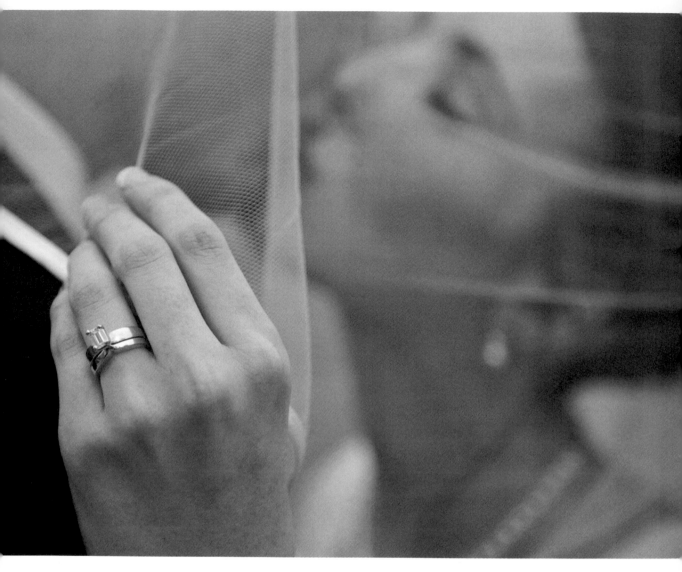

# Don't Forget the Details

On the wedding day, it's important for you to see the big picture, capturing all the fun and excitement. But it's also important to photograph the details, including the wedding ring(s), table placards, wedding cake toppers, etc.

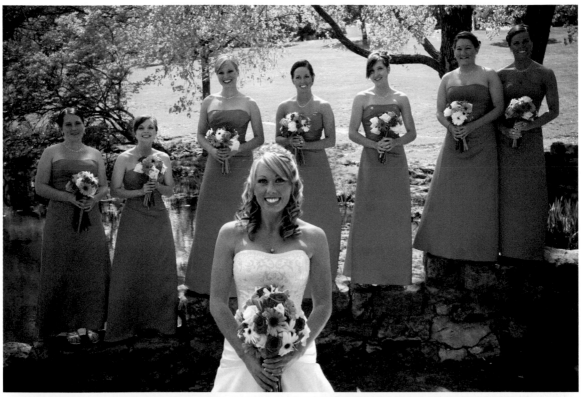

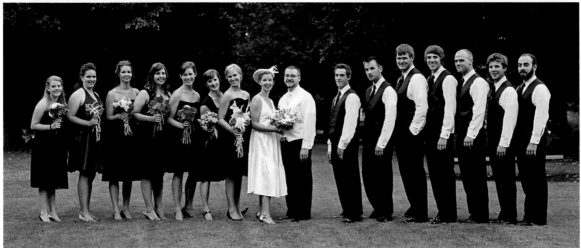

# Be Creative with Group Photographs

Check out these two images. The top image shows creative posing in a nice setting. The bottom image is a standard "get in line" shot. Before the wedding day, find out how many people will be in the group photos, and plan your shots—posing and location—accordingly.

## Utilize Nice Natural Backgrounds

The background of a photograph is critical, so scout the locations in which you'll be shooting and look for interesting backgrounds. Remember to always look up, down and back.

# Shoot from Creative Angles

If you want all your pictures to look the same, then take every one from a standing position … and shoot only the bride and groom when they are standing up, too. Ho hum! Want something different? Experiment with different poses and shooting angles; you'll get a much more interesting set of images. Important: Keep the comfort of your subject(s) in mind at all times. Don't ask them to do things they would not do naturally.

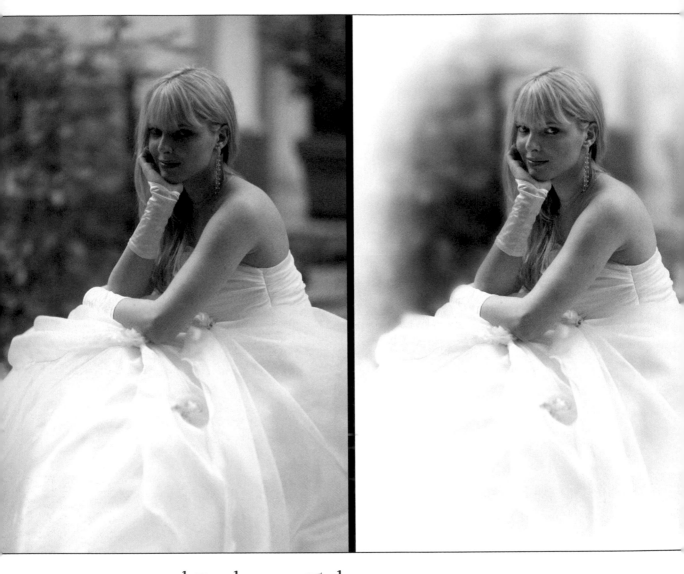

# Learn Digital Darkroom Enhancements

If you want to be competitive with other wedding photographers in your area, then learn Photoshop. Photoshop can not only save many a day by fixing some of your mistakes, but it also offers many creative enhancements that brides love! Don't miss the Photoshop section of this book.

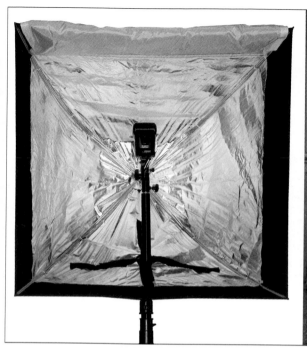
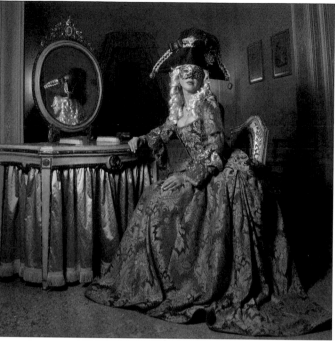

*Part 2*

There's an old saying, "Cameras don't take pictures; people do." It's true. However, you still need a good camera system, lighting gear, photo accessories and a computer to not only take pictures, but also to deliver photographs to your clients. In this chapter you'll find my gear recommendations—from start to finish—for a serious wedding photographer.

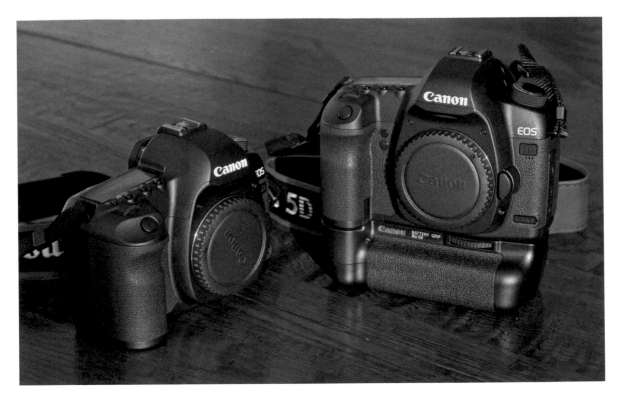

# Digital SLR Choices

There are a lot of digital SLRs out there that can help you capture a wedding in fine detail. However, not all Digital SLRs are created equal. Here are some things to consider when choosing a system:

- Sensor Size: By choosing full-frame, you can take full advantage of wide-angle lenses. Going with options that are smaller than full-frame means that your wide-angle lenses will record a narrower field of view.

- Accessories: Add-ons such as a battery pack/ grip (shown on the camera on the right) offers increased battery power that can save you from missing shots due to a battery change.

- Frames per Second: Be sure that the system you choose gives you a high number of frames per second (from 3 to 10, depending on the camera). This will help you avoid missing important action shots, such as the bride and groom running out of the church.

- Maximum Number of Frames per Second and Burst Rate: Know how many frames you can shoot before the camera "locks up" during the file-writing process.

- Maximum Flash-Synch Speed: Higher synch speeds are more advantageous for shooting in bright-light situations and for outdoor fill-in flash photography.

Of course, other functions, such as the buffer size and speed of the memory card, along with the file format being used, also affect performance.

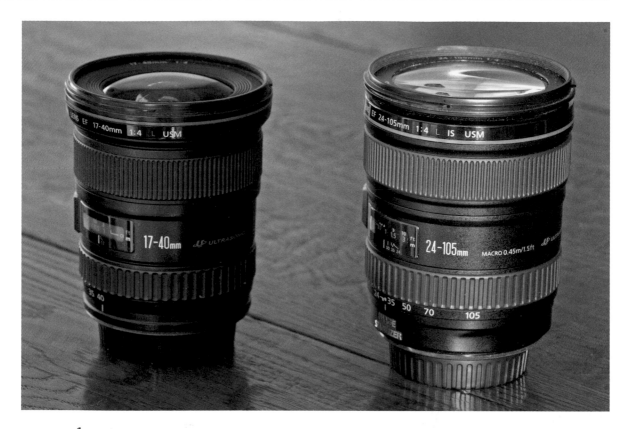

## Popular Zoom Lenses

For photographers on a budget, zoom lenses are the way to go. You'll need at least two lenses in the following approximate zoom ranges: a 17-40mm zoom for wide-angle shots and a 24-105mm zoom for portraits.

These versatile lenses are not as fast as fixed focal-length lenses. They have a smaller maximum aperture, which lets less light into the camera than faster lenses. Therefore, to get a good hand-held shot in low-light conditions, you may need to boost your ISO, which increases digital noise, or you may need to use a camera support.

Zoom lenses, however, are not only for the budget-minded photographer. They are also standard lenses for many established pros.

That said, some argue that photographs taken with zoom lenses are not as sharp as those taken with fixed focal-length lenses. Technically, this may be true, but I sure can't tell the difference in the prints I make or in the images that are reproduced in my books and magazine articles.

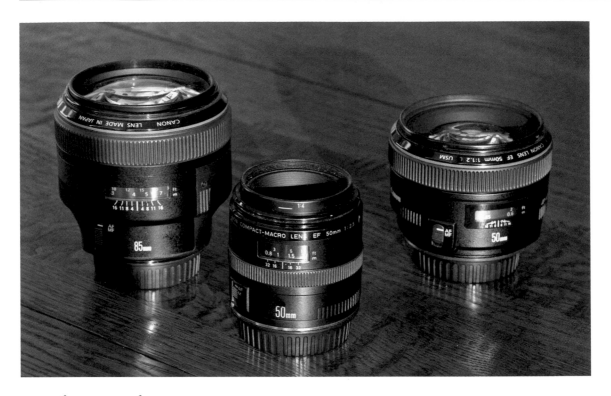

# Professional Portrait Lenses

The lens on the left, an 85mm f/1.2, and the lens on the right, a 50mm f/1.2, are must-have lenses for the serious wedding photographer. Not only are they super sharp, but the fast apertures let photographers use a relatively fast shutter speed in low-light conditions.

What's more, when set at its widest aperture, the f/1.2 offers very little depth-of-field when shooting a subject close up. This renders the background very out of focus, which generates a creative and popular effect among wedding photographers.

These lenses are costly. The 50mm lens runs about $1300, and the 85mm lens costs about $1700. If you are on a tighter budget, consider a 60mm or a 50mm macro lens (center), which cost about $400 each. Just keep in mind that these are less expensive because they're not as fast.

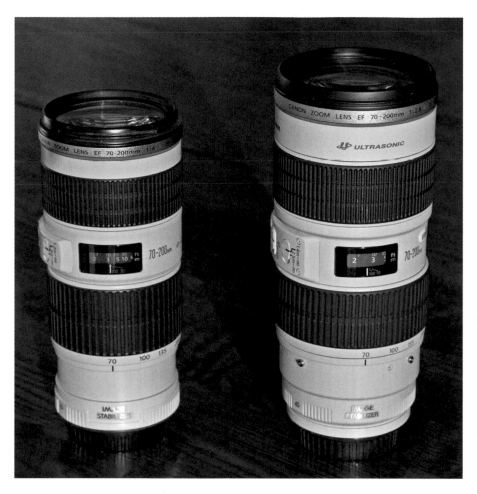

# Telephoto Zoom Lenses

You may not need a telephoto zoom lens at a wedding, but it sure is nice to have in your gear bag, especially when you can't get close to a subject or when you want to blur the background.

Pictured here are two 70-200mm zoom lenses, which offer a popular zoom range for wedding photographers. The lens on the left is an f/4 lens, and the lens on the right is an f/2.8.

You can see the difference in size. The weight of the f/2.8 lens is greater than that of the f/4 lens. Size and weight are things to consider when building a lens system.

Both lenses offer image stabilization (IS), which reduces the effect of camera shake. The f/4 lens is a little more affordable (at less than $1000) than the f/2.8 lens, which costs about $1200.

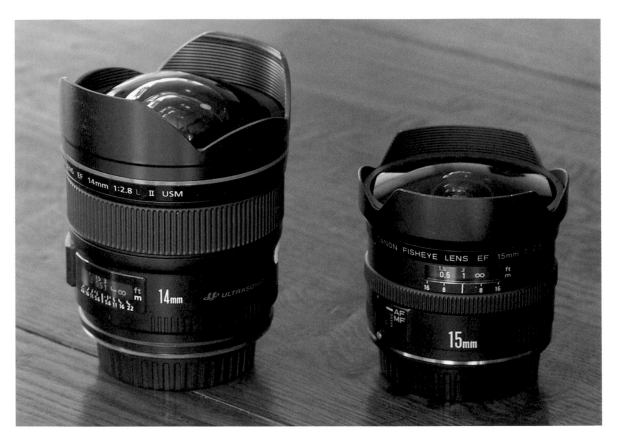

# Fish-Eye Lenses

You may not use a fish-eye lens too often, but it's nice to have one in your arsenal of accessories. They are a bit pricy, costing about $1500. If you can't afford one, renting it when needed is an option.

Pictured here are two types of fish-eye lenses. The lens on the left, a 14mm lens, lets you work in very small areas without any distortion (bending of horizontal and vertical lines). The lens on the right, a 15mm lens, also lets you work in small areas, but you'll see horizontal and vertical lines bend in your photographs. They'll bend even more as you tilt your camera up and down, and this can generate a nice, creative effect.

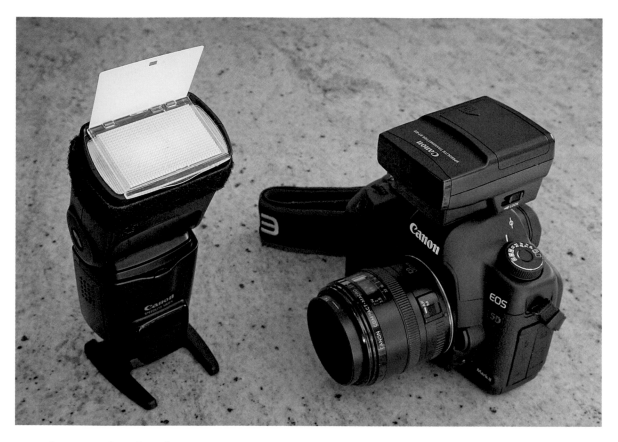

# Dedicated Flash

A flash is perhaps your most important accessory. Most pros use dedicated flash units, which are flash units made by the camera's manufacturer. This enables you to take advantage of all the flash's exposure capabilities.

When purchasing a flash, look for one with what's called *variable flash output*. With this feature, you can adjust the automatic flash output over and under the correct (or standard) setting. This is especially important for daylight fill-in flash photography, which is covered later in this book.

You'll also want a flash with a built-in diffuser (shown here over the flash head) and a pop-up white card (shown in the popped-up position). Both devices help to soften and spread light for a more natural-looking photograph.

A wireless transmitter, which mounts in a camera's hot shoe, is a valuable flash accessory. It lets you fire a remote flash, or a set of flashes, for more professional-looking and creative photographs.

When choosing a flash, also check out its maximum flash range, the number of flashes per set of batteries, and its synch speeds.

# Tiny Tripod

Hey, I know you have a sturdy tripod for those low-light shots, indoors and out, but for low-level shooting, a tiny tripod, such as this model from JOBY Gorillapod (www.joby.com) can come in handy.

Later in this book, you'll see some shots of an altar that were taken from a very low height. Those types of shots often require a long shutter speed. So if your standard tripod can't adjust to shooting very low to the ground and you don't want to lie on your belly in the aisle, you'll miss this type of creative shot without a tiny tripod.

The Gorillapod can also wrap around a branch or fence post for steady shooting outdoors. It's a fun accessory that can also save the day when the light level is low.

# Apollo Speedlite Kits

I know this is not a shot of a 2009 bride, but you could light a bride of today just as beautifully... and just as simply. The lighting set up for this shot was easy. It's a one-light shot that I took in Venice, Italy.

You already have at least one accessory flash. Mount that inside an Apollo Speedlite Kit from Westcott (www.fjwestcott.com) and you thereby increase the size of the light source and soften it at the same time. Just unfold the diffuser panel (shown above) and secure it in place with Velcro.

For the photograph on the right, the Speedlite Kit was positioned about 10 feet from the subject at a 45-degree angle. I triggered my Canon Speedlite 580EX with my Canon Wireless Transmitter ST-E2.

Using a slow shutter speed, I was able to capture some of the available room light for a natural-looking photograph.

Of course, you can use multiple Speedlite kits for even more creative lighting.

As with all lighting set ups, try positioning the lights at different distances from the subject and at different heights to capture the shot you envision.

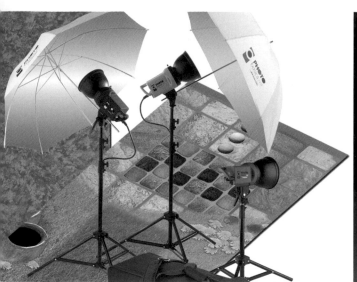
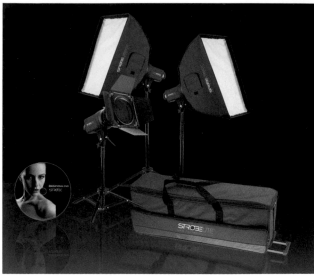

# Basic Hot Light and Strobe Light Kits

If you are just starting out and on a small budget, there are affordable ways to create studio lighting. There's no need to spend big bucks on expensive studio lighting equipment.

The most economical route is a hot-light system, such as the one from Westcott (www.fjwestcott. com) that's pictured on the left. The hot lights provide a constant light source, and the umbrellas diffuse the light for a soft and flattering effect. Two lights, two umbrellas and a background/ separation light are included in this kit—all for under $700.

A step up from a hot-light kit is a strobe-light kit, such as the one pictured here on the right, also from Westcott. Three lights are included: two fill lights that mount inside included soft boxes (for a soft and flattering effect) and a background/ separation light. This kit costs under $900.

These kits, which set up in minutes, come with a carrying case, so you can even take them to the bride's house for a few quick studio-type portraits.

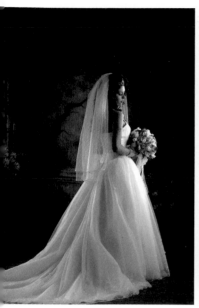 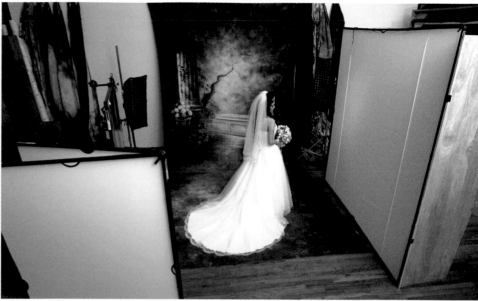

## Scrims

If you have the space, and the time, scrims can help you create very professional-looking photographs. As you can see in the picture on the right, a scrim is basically an extra-large diffuser, somewhat like a large sheet. It's used to soften and spread the light, whether it comes from a flash, hot light or strobe that's placed behind it. Scrims can also be used to soften natural light, such as light coming through a window.

The result of using a Westcott Scrim Jim is shown on the left.

Photographs courtesy: Claude Jodoin

# Portable Backgrounds

A background can make or break a photograph—any photograph. You can ensure that you'll have a good background (one that looks professional) on the wedding day by keeping a portable/collapsible background in the trunk of your car.

Portable backgrounds, such as the one shown here by Westcott (www.fjwestcott.com) come in all sizes, shapes and colors. Pack one (or two) with you on the wedding day, and you can create studio-type portraits indoors and out.

In case you were wondering about that black cloth on the floor, I placed it there to eliminate the reflection of sunlight off the floor, which would have created unflattering bottom light (also known as Halloween light) on my face.

Photographs by Marco Sammon

# Diffuser Panels

Brides love bright, sunny days. The camera, however, does not love the results of brides illuminated by harsh sunlight, which casts unflattering shadows on the face.

For professional photographers, that's no problem. They usually ask an assistant, or even a guest, to hold a collapsible diffuser between the sun and the subject to diffuse and soften the light. This before-and-after pair of pictures illustrates the dramatic difference a diffuser can make.

Diffuser panels, available in different sizes, are often sold in kits along with reflectors, which are described on the next page.

The behind-the-scenes shot at the end of this chapter illustrates correct diffuser placement. I took the shot indoors to illustrate diffuser placement, which is between the light source and subject. I used one direct-light position above the subject to simulate the type of light that you'd naturally encounter on a sunny day.

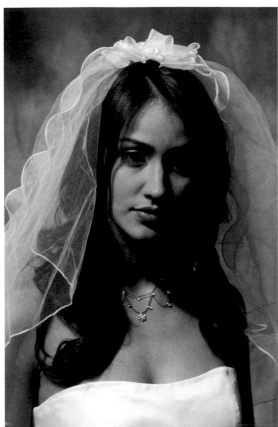
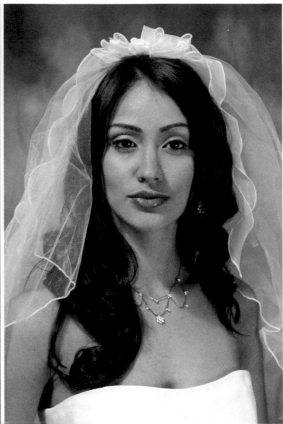

# Reflectors

Reflectors, which usually have a gold side and silver side, are used to bounce direct light onto a subject's face for a more flattering effect. Reflectors reduce the contrast range in a scene while adding either a warm glow (gold side) or a cool glow (silver side) to the subject's face.

Here you can see how holding a reflector on the opposite side of a single harsh light source (used here to simulate bright sunlight) beautifully filled in the harsh shadows on the bride's face.

You can also use reflectors inside, where you can bounce light onto the shaded part of a subject's face when (s)he's standing by a door or window.

Reflectors are typically sold in kits with diffusers. Westcott offers many models to fit your needs.

There are other practical uses for diffusers and reflectors, too. Use a diffuser to soften the light from an accessory flash by positioning the diffuser between the flash and the subject. Use a reflector to increase the size of an accessory flash by bouncing the light from the flash into the reflector.

The behind-the-scenes shot at the end of this chapter illustrates reflector placement. As with the diffuser example, I took the shot indoors to illustrate correct reflector placement—opposite the light source.

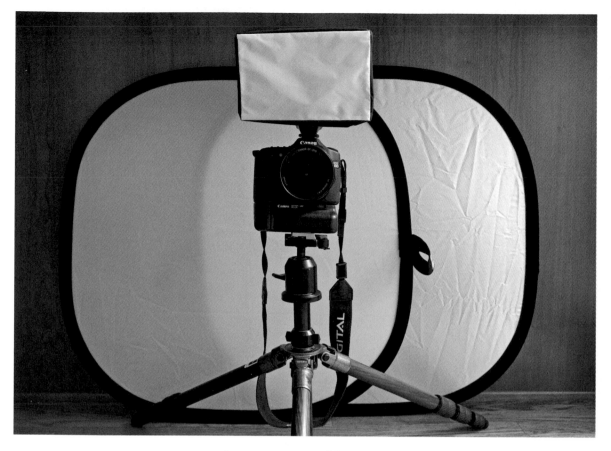

## My On-Location Light Controller and Tote

My own reflector / diffuser kit is available for purchase; it's called Rick Sammon's On-Location Light Controller and Tote. The kit also includes a flash diffuser, which softens the light from an accessory flash for a more pleasing and natural-looking photograph. The handy tote carries it all and comes with a flash, memory cards, extra batteries...and even a copy of this book!

I developed this kit to provide an affordable product that photographers could use to control the light. It's easy to do with a little know-how, and it often makes the difference between a snapshot and a great shot.

# Home Computer System

Your home computer system is a vital part of your wedding photography business. My advice is to get a system that has as much RAM as you can afford. That way, when you are reviewing your photographs side-by-side with your clients—and perhaps tweaking your images in Photoshop or applying filters and special effects—your computer will be able to "think" fast. This will help you show off your work at top speed.

I also suggest getting the largest monitor you can afford. This will make it easier for you and your clients to view your work together—during the review process and for sales pitches to couples still deciding on a photographer.

Of course, calibrating your monitor to show colors accurately is of key importance. Also be sure to keep the light in the room constant, so that images on the monitor will always look their best.

Last but not least, always remember to back up your images—in at least two places—ASAP after a wedding shoot. You just never know what can happen when working with hard drives!

## Portable Computer System

On occasion, you may find yourself working away from home. In those cases, you'll need an on-location computer system that's complete with back-up drives.

My advice is to select your "keepers" offsite, but wait to edit your images with Photoshop until you get back home. Although your portable monitor may be calibrated, the light in the room will be different from the light in your studio's digital darkroom or in your den at home. Thus, you may be fooled into making mistakes in digital adjustments when you're offsite.

As far as memory cards go, bring more than you think you'll need—even if you have a portable download device, such as the Epson P7000. It could crash. It's a hard drive.

Keeping all your photographs on your memory cards until the end of the day is the safest way to go. Just keep those precious cards in a safe place! They are worth much more than their weight in gold.

When traveling, take a back-up card reader and cable. Again, these devices have been known to fail, and that's something you simply must prepare for.

# Printing Your Own Work

With today's printers and pigment-based inks, it's easy for you to make archival prints for your customers. What's more, you need prints for your office or studio walls and for sample albums. Most likely you'll change these often as you get new and exciting images.

Having your own printer puts you in total and instant control of making prints. Just make sure that your printer is calibrated and that you are using the correct ICC profile for it. Using the manufacturer's ink and paper is also recommended.

You may have heard this photo joke: If you can't make a good print, make a big one. It's actually not that far fetched. Bigger can, in some cases, look better. And you can sell a big print for more than you can sell a small print.

When choosing a printer, you need one that makes at least a 13x19-inch print, such as the Canon Pro 9000 shown on the right. For 24-inch wide prints, you'll need something like the baby on the left: my Canon iPF6100. Use roll paper in this printer to make a life-size image of a bride or groom.

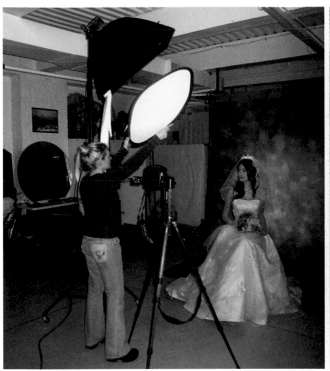 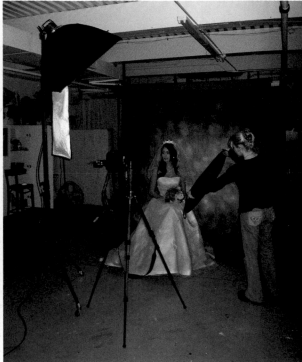

# Behind-the-Scenes with Diffusers and Reflectors

Here are two snapshots that illustrate how to position a diffuser and a reflector. The harsh studio strobe, placed above the subject and to the left, was used to create the type of light you'll find on a bright, sunny day.

The picture on the left shows Vered Kashlano, the studio's owner (and a wonderful photographer herself), holding a diffuser between the light source and our model, Stephanie Garcia (not an actual bride, by the way). The diffuser panel is actually translucent—not the yellow color it appears to be in the picture.

The picture on the right shows Vered holding a reflector to bounce light onto the shaded side of Stephanie's face.

If you are flipping through this book backward, flip a few pages forward to see the end-result images of all this hard work.

In case you are wondering about that thing sticking out of my camera's hot shoe, it's a wireless transmitter that fires the flashes.

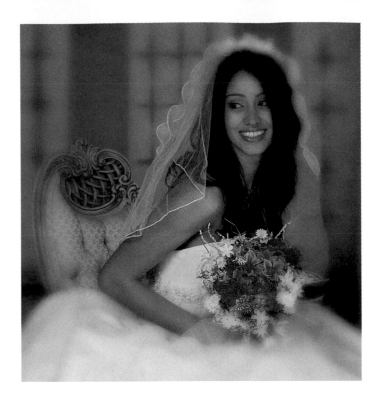

*Part 3*

# The Studio Shoot

You'll find a lot of candid pictures in this book; they seem to be the current trend in photography. You'll also find some wonderfully posed images by some of today's top pros. However, you will not find many studio shots, as most brides and grooms are too busy for a studio shoot these days, or they just prefer on-location photographs.

That said, it's very likely that, in time, you will encounter wedding couples who want studio shots. It's important that you are able to provide them.

In this chapter, you'll find some basic studio lighting tips ... for those occasions.

I took all these photographs in Vered Koshlano New York City studio. She assisted with the photographs, but she is an excellent photographer herself. Please check out her site: www.byvk.com.

And heads up: I could not resist! I had to mention and illustrate some Photoshop enhancements, as they seemed to apply nicely to some of these images.

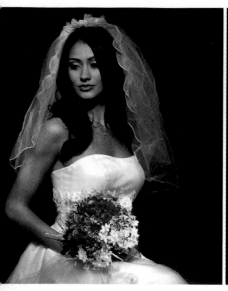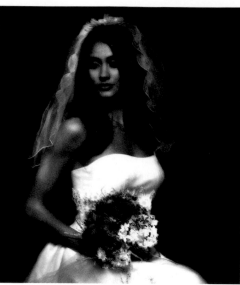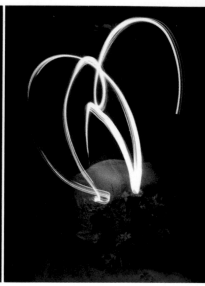

# Painting with Light

This chapter begins with one of the most basic and affordable types of artificial lighting: a flashlight.

That's right! You can create beautiful portraits by illuminating your subject with an inexpensive flashlight. Basically, the technique is to "paint" the subject with light. I used a $5 flashlight to create the picture on the left. Here's the deal.

Set your subject in an almost completely dark room.

Mount your camera on a tripod. Set the ISO to 400 and the f-stop to f/8. Then select the self-timer mode and be prepared to experiment with shutter speeds from five to ten seconds (depending on the brightness of your flashlight).

Ask your subject to hold perfectly still. Perrrrrrrrrrrfectly still!

Release the camera's self-timer while the shutter is open and use the beam of the flashlight to paint the subject with light.

You'll have to practice this technique to get it just right. It will take you a few attempts to get the correct exposure and the right amount of illumination on your subject.

The center picture on this page illustrates use of the Midnight Filter from Nik Software applied to my original image. The picture on the right illustrates what happens when the flashlight is pointed at the camera. Clearly, this is something you need to avoid.

See the end of this chapter for a behind-the-scenes look at this creative technique.

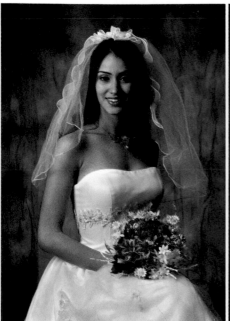 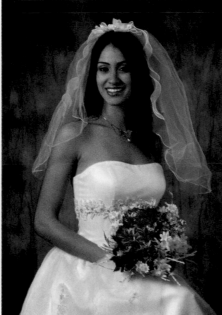 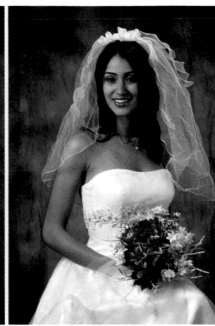

# Basic Three-Light System

You don't need a ton of lighting equipment to get professional-quality photographs in a studio—whether it's a full-time studio or a home studio. Here you see the results of using a basic, three-strobe-light studio lighting system, which includes a main light, a fill light and a hair light.

Left: One strobe light, which is the main light, is placed in a soft box and positioned above the subject's eye level and at camera left.

Center: Same as above but with a second light—a fill light that's set to half power to fill in the shadows on the subject's face—placed above the subject's eye level and at camera right.

Right: Main light and fill light are set up as described for pictures on the left and in the center. A third light, a hair light (set at one-quarter power), is placed behind the subject and off to camera right. This slightly illuminates the subject from behind to add a slight glow to her hair and veil. Look closely and you'll see the subtle effect of the hair light.

See the end of this chapter for a behind-the-scenes look at this basic lighting set up.

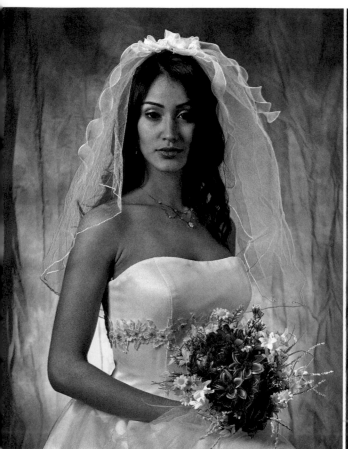
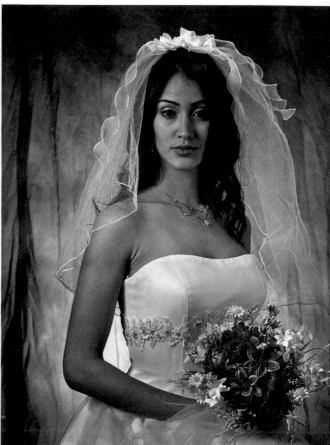

# Change the Color of the Background

Compare the color and intensity of the background in this picture to the background shown on the previous page. It's the same background. But here it looks golden and much brighter.

That's because a background/ separation light (a fourth light) was placed behind the subject and pointed toward the background. An orange gel was placed over the background light to change the perceived color of the background from blue/ gray to bright sunset orange.

In the picture on the right, the background color is even more intense because I selectively increased the saturation of the background in Photoshop.

If you don't have a lot of different backgrounds, pick up a few gels (available from professional camera stores) for your background light and change its color instantly—and affordably.

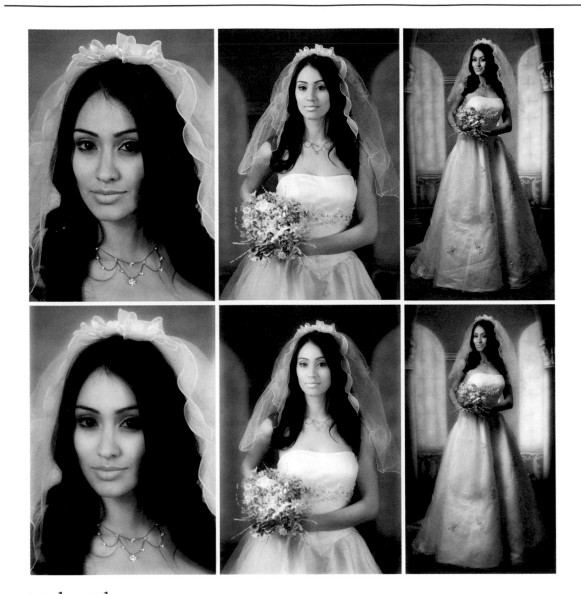

# Take Three

Whenever I photograph a person, in a studio or foreign country, I always take three shots: a headshot, a three-quarters shot and a full-length shot. That way, I have three options to choose my favorite image. In the case of a bride, she gets three pictures from which to choose.

On the top row you see my out-of-the-camera shots. They were changed to black-and-white in Photoshop.

On the bottom row you see the effect of Photoshop's Diffused Glow filter, which makes the images look more artistic. What's more, using that filter with the Clone Stamp tool helped me to "iron" the bride's gown and remove some of the wrinkles.

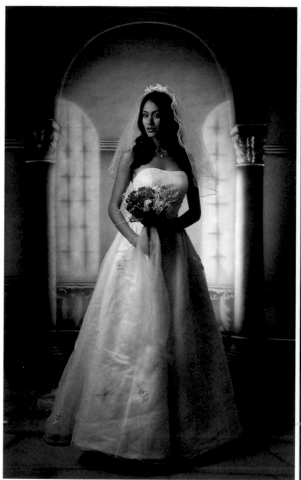
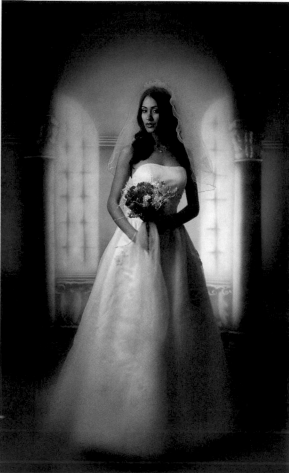

# Begin with the End in Mind

As always, it's important to envision the end result when you are photographing, whether you are going for a straight shot or a Photoshop effect.

To get a sharp shot of a subject positioned in front of a painted background, be sure to carefully adjust the lights to evenly illuminate both the subject and the background. For this shot, I envisioned and tried to create a photograph in which the model would be sharper and brighter than the background. I got that shot.

I also wanted to create an artistic image. And since I was not thrilled with the green tone of the background, I used the Color Replacement tool in Photoshop to change it to blue. Then I used the Vignette Blur filter in Color Efex Pro from Nik Software (www.niksoftware.com) to blur the outer edges of the frame.

Finally, as with the image on the previous page, I ironed the gown using the Clone Stamp tool.

# Experiment with Creative Poses

The picture on the right shows a model in a standard pose. It's an okay shot, but it's not that creative.

The picture on the left shows a more imaginative pose. It was created by asking the model to simply lean forward and position her head directly at the camera, and then look off camera to her right so that more of the whites of her eyes show than in the picture on the right.

I used two Photoshop techniques for that photograph. The Vignette Blur effect that you saw on the previous page is obvious. I also used the Dodge tool to brighten the whites of the model's eyes— to draw more attention to them. This is a standard technique of photo-retouching artists, and it's one you have seen many times on the covers of fashion and glamour magazines.

Check it out the next time you go though the checkout line at the supermarket. You'll see that the whites of the models' eyes are almost as white as the paper on which the magazine is printed. That's Dodge.

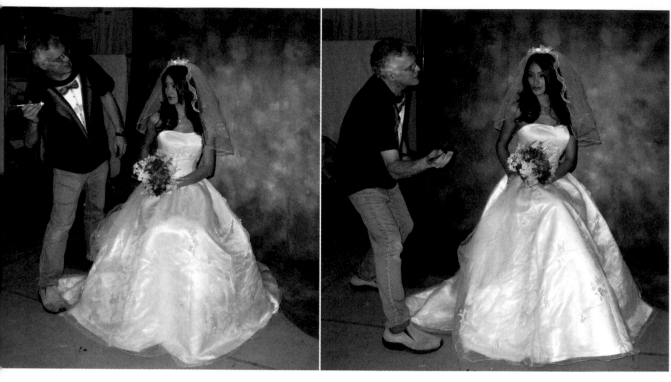

# Behind the Scenes: Painting with Light

Here you see me demonstrating the painting-with-light technique, using my trusty $5 flashlight. As I mentioned earlier in this chapter, the idea is to paint your subject with the beam of a flashlight, moving around to simulate the effect of using several lights.

The picture on the left illustrates something else: When working near a bride, make sure you don't step on her gown! Oops! Sorry!

Watch your step.

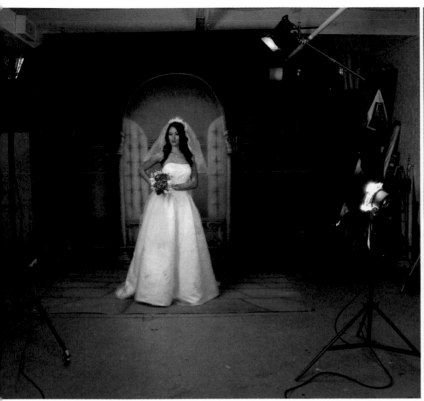

# Behind the Scenes: Three-Light Set-Up

Earlier in this chapter you saw the effect of using a three-light set-up. See that set up here.

On the left is the main light; on the right is the fill-light; and at the top right of the photograph is the hair light.

All these lights have built-in modeling lights that illuminate the subject before the strobes are fired. These modeling lights help you position the light stands so you can avoid— or create—shadows.

The modeling lights can also be used to create soft, continuous-light photographs—as illustrated by the portrait of Stephanie you see here on the right. I applied Photoshop's Diffuse Glow filter to create an even softer effect.

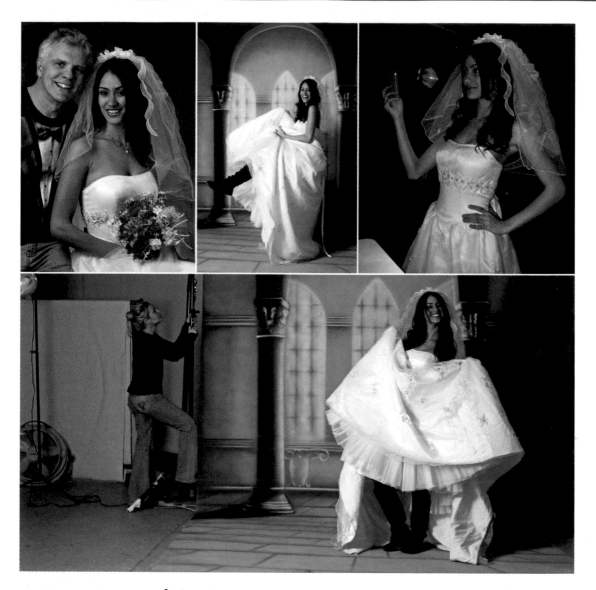

# Don't Forget the Fun!

Simply put, the more fun you have during a shoot, the more fun your subjects will have. I like to make photography fun.

In fact, I work hard at making photo sessions fun. I wear fun clothes, take fun shots, get in the shots and take behind-the-scenes shots. Subjects really like these, because they can joke around and be themselves without having the pressure of looking great!

If you keep it fun, you'll end up with more "serious" pictures that your clients love.

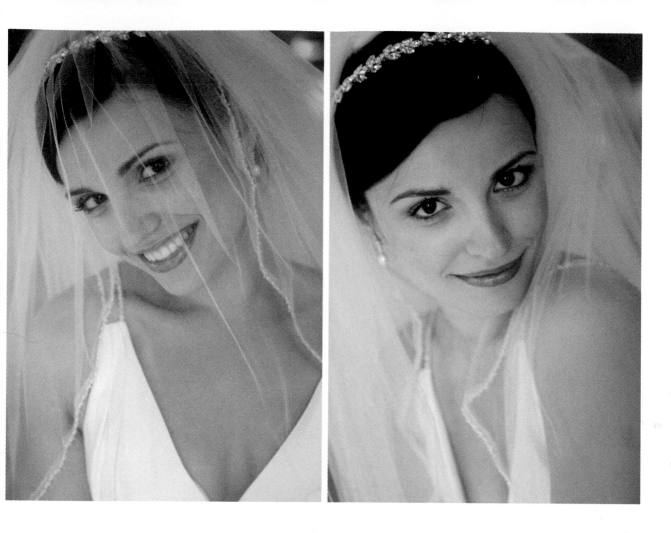

# Part 4

## Weekend Wedding Photographer

My guess is that you're not a full-time wedding photographer. Yet!

For those of you just starting out, the information in this chapter will help you understand how to capture a wedding for brides and grooms who want candid photographs.

These tips—illustrated with Canada-based photographer Davide Greene's work—prove that you don't need fancy gear or techniques to get the kind of shots you and your clients will love.

But you do need a positive attitude and a penchant for fun.

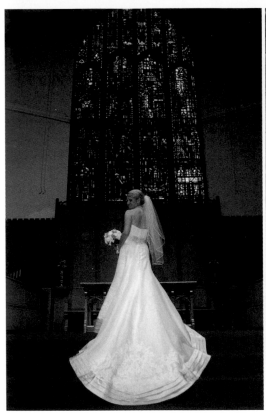 

# Shoot Candid and Formal Photographs

As you can tell from the photographs in this section, Davide Green is not big on posed shots. Neither are his clients. That's because he mostly shoots like a photojournalist, capturing what he sees without a lot of set up.

That said, Davide does take posed shots, as illustrated by the image on the left. But when he has his choice, he sticks to shooting candid photographs. He believes they capture the real fun, excitement and emotion of a wedding.

His advice is to learn how to shoot like a photojournalist as well as a portrait photographer. Watch for artfully posed photographs throughout this book; they represent both types of photography. Each style has an important role in wedding photography.

For candid photographs, you must think quickly. Your camera must be set up and ready to go. There's just no time to fuss with camera settings on the spot.

For portraits, you need to pay close attention to the light and, of course, the subject's pose and body motion.

In both situations, be sure to take more than a few shots. Vary your angle as well as the crop and composition of the scene. And have fun! If you enjoy the process, your couple will, too.

# When Color is Preferred

This is one of Davide's most colorful images. As you'll see throughout this section, Davide loves black-and-white photographs. However, when color is a key component of a scene, it's important to show it.

To get good color, Davide suggests setting your white balance to the lighting conditions for the scene … even if you shoot RAW. Of course, you can tweak the color of an image in Camera RAW, but if you start out with the correct white-balance setting, you'll have a better chance of getting it right in camera. This will save you time in post processing.

If you shoot JPEGs, remember that when the image files come out of your camera, they will already be sharpened with an increase in saturation and contrast. These factors can affect color and detail. Also keep in mind that if you shoot JPEGs, you can open them and work with them in Camera RAW if you have CS3 or CS4 or Canon's Digital Photo Professional.

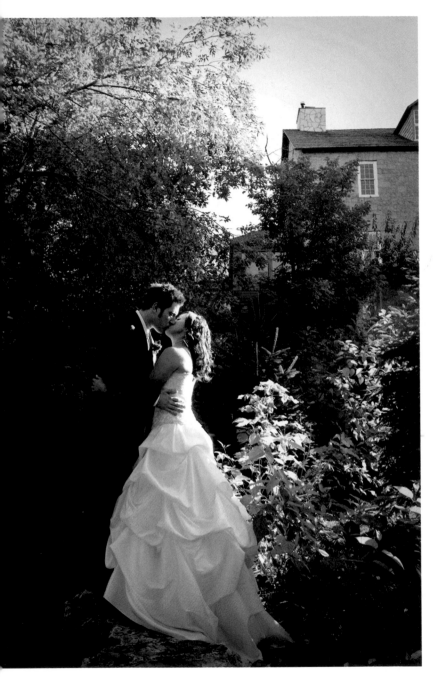

# Envision the Black-and-White Image

This is one of Davide's favorite black-and-white photographs. If you have ever wondered why black-and-white photography is so captivating, consider this: When you remove color from a scene, you remove some of the reality. And when you remove some reality, your image becomes more artistic.

Black-and-white photographs convey a sense of lasting importance. Wedding couples like black-and-white images for these same reasons.

Yet as much as Davide likes black-and-white photography, he shoots all his images in color. This gives the bride and groom options.

When you photograph, always shoot with shades of gray in mind, and try to pre-visualize how a scene will look in black-and-white.

What's the best way to create a black-and-white in Photoshop? Check out the Photoshop section of this book for some ideas.

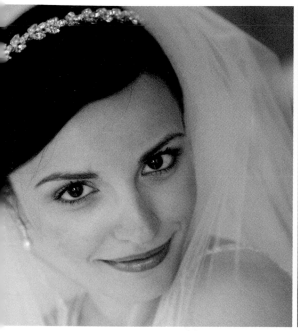

# Shooting Head Shots

The most important portraits you'll take on the wedding day are the bride's headshot and her head-and-shoulders shot.

Before you set out to photograph the bride, consider this philosophy: The closer you are to the subject, the more intimate the photograph becomes. So, rather than using massive telephoto lenses, try photographing with a 24-70 zoom at about a 70mm setting. This lets you work just a few feet away from your subject.

Also try shooting at a wide aperture, f/2.8 to f/4.5, to throw the background out of focus. This draws more attention to the subject.

Sometimes, shoot eye-to-eye, which is a time-proven tip in portraiture. But don't neglect an attempt at shooting above eye-level, as illustrated in the picture on the left. It will result in a photograph with a creative angle and effect.

Usually, photographers like to light the eyes or have enough natural light illuminating the eyes to get some catch light. This is illustrated in the photograph on the left. But, as you can see in the photograph on the right, sometimes not seeing the eyes works. Even having the bride's eyes closed works, too . . . as if the bride is in deep thought.

The idea is to take enough pictures from enough angles to please your client with your results.

Here is another important tip for when you photograph a subject: *Silence is Deadly*. Throughout the portrait session, constantly talk to your subjects; it keeps them from feeling self-conscious and bored. Plus, when chatting, a person's natural expressions show on his/ her face.

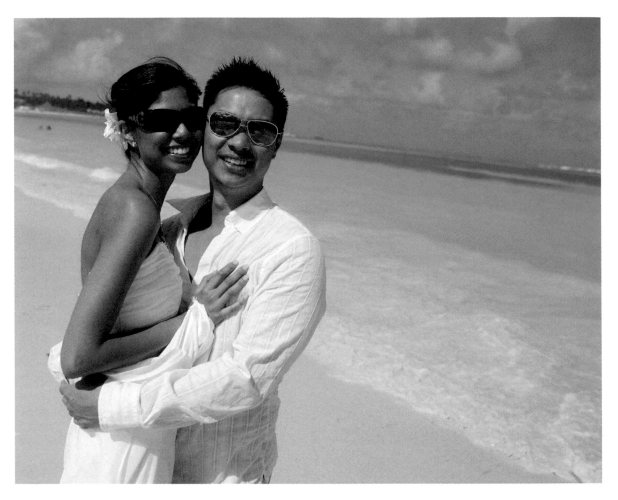

# Get the Three-Quarters Shot

The main tip here, as funny as it may sound, is to try not to amputate your subjects at the knees or ankles. Actually, it's a good tip for other joints as well. You don't want to amputate a subject at the wrist or elbows either.

As long as there is space on this page for photo advice, here is another tip: When composing a photograph, try not to place the subject dead center in the frame. Dead center is deadly.

When you place a subject off center, the viewer of your photograph will look around for other interesting stuff in the scene. Therefore, this type of image holds attention a bit longer.

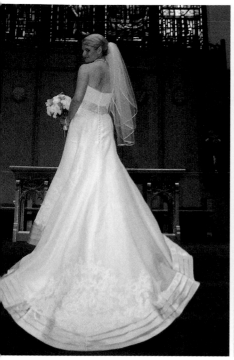
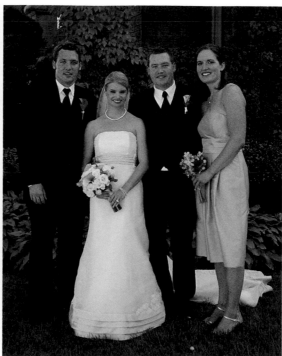

# Brides Love the Full-Length Shot

Hey, the bride spent big bucks on that gown, and it's important to her—from head to toe. And what about all those new shoes that the bridesmaids bought for the special occasion? They are important, too!

Don't miss these shots.

And remember to carefully check the bottom of your viewfinder, especially if you wear glasses, to make sure that you get just what the wedding party ordered.

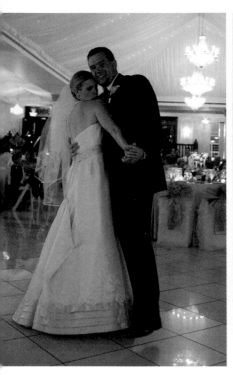 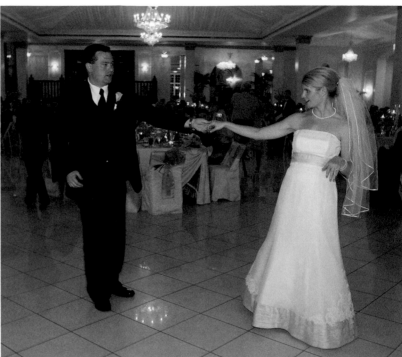

# Get Good Color Indoors

Good color is different from accurate color. Go for both when you photograph.

In the picture on the left, the couple looks a bit pink. This is a result of the pink spotlight that is illuminating the dance floor. Sure, the color is not right if you are looking for 100% accurate skin tones, but it was accurate for this situation. What's more, the pink tone of the image helps to capture the mood and feeling of the moment.

When shooting in situations like this, set your white balance to automatic; this will help you navigate variable lighting conditions. You may also need to set your ISO high, sometimes as high as 800. This will give you a shutter speed of around 1/125 of a second, which is fast enough to hand hold the shot and blur subject movement while preventing a blurry picture caused by camera shake.

A flash was used to take the picture on the left. As you can see, the skin tones look more natural. The couple loved the shot, because it shows them clearly. However, the harsh flash takes away from the mood of the setting.

When using a flash indoors (as well as outdoors), try to balance light from the flash to available light. This helps to reduce shadows. See page 68 for more on this topic.

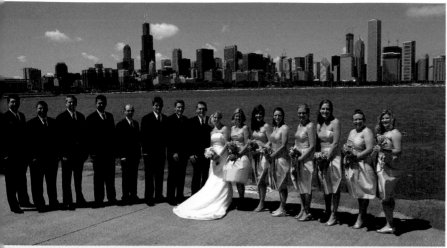

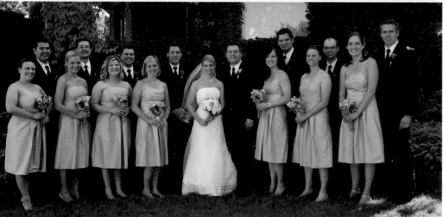

# Choose the Best Background

One of the greatest challenges of wedding photography is finding a good background for group photos. It's why it's so important to scout the location in advance.

The background must be plain and simple, and large enough to accommodate the entire group.

Carefully choose … and watch the background. It will result in images that show your subjects standing out, as illustrated in both of these photographs.

If you do find yourself in a situation where the only background is a busy scene, use a telephoto lens set at a wide aperture to throw the background out of focus. Just make sure that, in doing so, you don't throw any of the subjects out of focus, too.

# Blur and Blowout the Background

You've seen this technique in fashion and beauty magazines. It's where the photographer uses a telephoto lens set at a wide aperture to put a background out of focus. It's an effective technique for drawing interest to the subject.

You can make a photograph like this even more interesting and creative if the background is overexposed. To do that, simply position your subjects in a darker area than the background, and set your metering for the subjects.

Be careful when using this technique. It does not always work, because the background can become so overexposed that it looks as though you made a mistake.

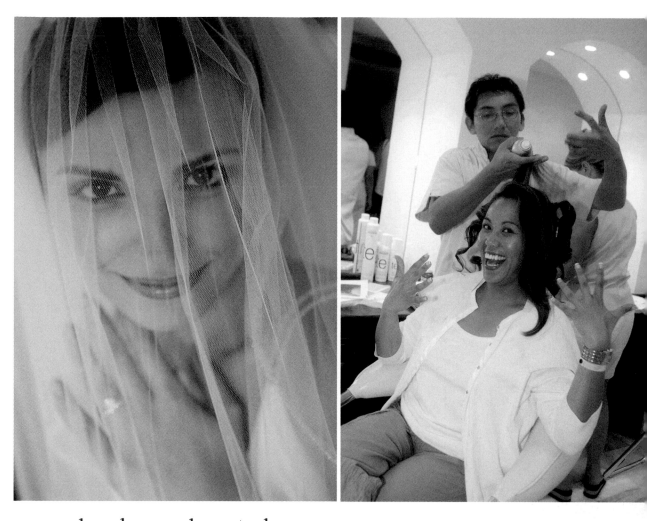

# Consider the Bride's Feelings

Check out these two pictures. One is a formal shot and one is a candid photograph. Both capture the mood and feeling of the bride, and this should always be a priority for you.

It's essential that you are tuned in to how the bride is feeling throughout the wedding day. You never want to intrude, and sometimes you need to back off.

After all, the bride is letting you into one of the most important days of her life. You have to honor it as a privilege so she can be herself. And when she feels natural, she lets you capture genuine feelings and emotions. This definitely comes through in photographs.

# Hang Out

Okay, so you got the job. You—and your clients—want to get the best pictures ever. How you approach this isn't necessarily obvious.

The technical stuff is the same from job to job; that's relatively easy to master. The challenge is to capture the personalities of the soon-to-be newlyweds and to thrill them with your pictures. In addition to the obvious reason for this, you want them to gush about you to their friends and family.

To get familiar with the couple, if you can work it out, try to spend a few hours with them, hanging out and taking snapshots—several weeks before the wedding. Take a few shots and show them to the couple. Ask them what they like and don't like about the pictures, and shoot them again. You may find that they prefer loosely cropped pictures over tightly cropped pictures, or vice versa, as just one example.

This effort on your part shows the couple that you are interested in pleasing them, and it makes the entire process more fun and interactive. It also helps a couple feel comfortable in your presence, which improves the chances that they'll relax in front of the camera on their wedding day—and allow you to capture authentic moments.

When hanging out, try to shoot in lighting conditions that are similar to those you expect for the wedding day. And be sure to build the session into your price.

Remember to give the couple these fun shots that precede the day they tie the knot.

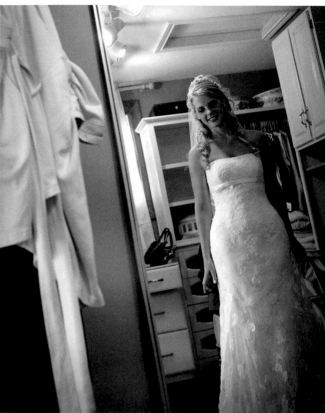

# Hit the Ground Running

On W-Day, you must hit the ground running—and not stop until the very end of the day. This means you have to start documenting the day from the moment you are welcomed into the bride's house. That is not the time to fumble around with camera settings and gear.

Keep it simple and travel light. Many wedding shooters use a 24-70mm f/2.8 lens on one camera body and a 50mm f/1.2 on a second camera. Both are typically strung over a shoulder so the photographer is ready to shoot a variety of subjects in a range of lighting conditions. And many use a zoom lens for most shots. They use the 50mm lens set at a wide aperture for low-light shots and to blur the background.

For weddings, it's generally a good idea to set your camera on the Av mode (aperture priority), because depth-of-field is so important for this type of setting. A general guideline is to have the ISO set to 400, or even 800, so you can shoot hand-held pictures in natural light. Also, be sure to set your flash for automatic exposures.

Of course, you also need your back-up gear—batteries, memory cards, etc.—in your camera bag, but keep it simple.

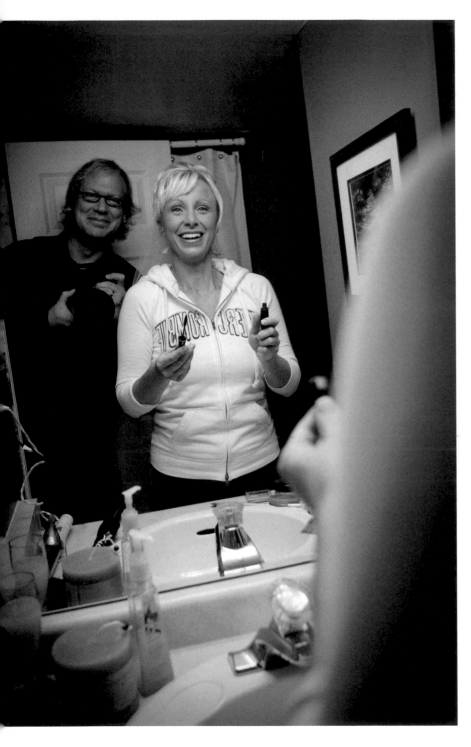

# Join the Fun

That's photographer Davide Greene next to the soon-to-be bride. He took this shot for fun, but the bride loved it because it captures a fun memory of an important part of her special day.

When you join in the fun, you become part of the wedding "party," rather than isolating yourself as a hired hand.

This is a hand-held shot with no flash. Davide's ISO was set to 800, and he used his 24-70mm lens set to 24mm to capture as much of the scene as possible in a small area. Keep in mind that you may be working in small spaces. Prepare for shots like this by carrying a wide-angle zoom or wide-angle lens.

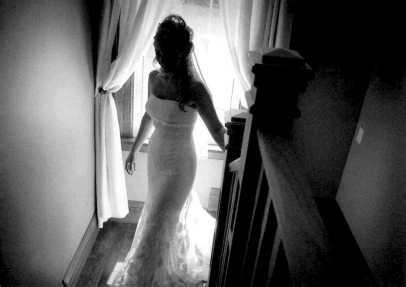

# Create a Mood

The bride in these photographs loved these images, even though we can't see her face clearly in either of them. It's because the back lighting created a mood.

Photography is all about light. It's light that makes a picture look flat or vibrant or moody. So it's important to learn how to see the light. Look for the contrast in a scene and consider the color and direction and quality of the light.

The message here is that every picture you take does not have to show an evenly illuminated face.

Work with the light and play with the light, and you'll get creative pictures. Also remember this photo adage: *Light illuminates; shadows define.*

For these two shots, the camera was set on Av (aperture priority) without any exposure compensation. Stopping down (i.e., setting a small aperture) in this type of situation would have darkened the light coming through the window for a "correct" exposure. So sometimes it's good to break the rules.

That said, if you want to darken the window here (which will also darken the subject), stop down by an f-stop or two.

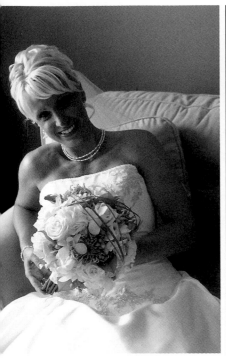 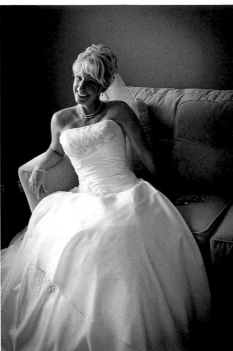 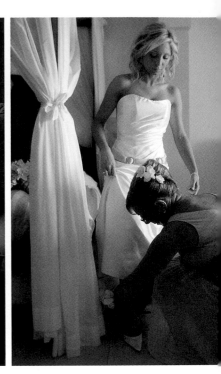

# Go for Rembrandt Lighting

All these photographs have something in common: Rembrandt lighting.

Rembrandt, the famous Dutch painter and printmaker, had a beautiful studio with a huge window that cast exquisite light onto his subjects. He painted many subjects in that light, which generally illuminated one side of their face, and the style has come to be known as *Rembrandt lighting*.

Wedding photographers use Rembrandt's idea often. To do it, you first need to find a nice setting with plenty of window light. Then you need to position the subject in a flattering pose. Before you take the shot, set your exposure compensation to −1/2 EV so the side of the bride's face that is facing the window is not overexposed. If it is, stop down even more.

When using this technique, check your histogram to make sure you don't lose those all-important highlights on the bride's face. You're due for overexposure if you see a spike on the right side of the histogram.

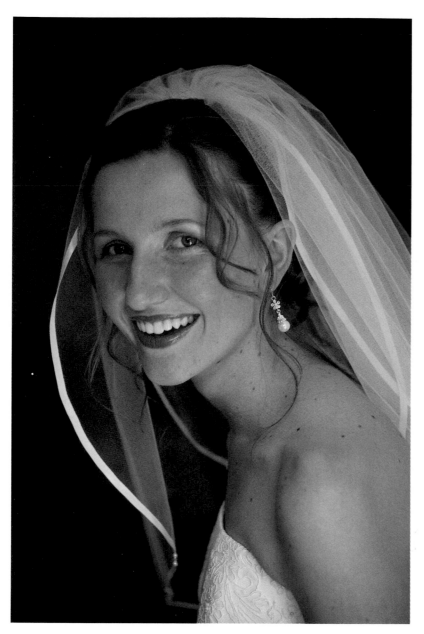

# Capture that Beautiful Catch Light

Look at this bride's eyes, and also those of the bride in the Here Doggie Doggie section on page 64. Then, go to the trio of pictures on the second-to-last page in this chapter.

The eyes in all these photographs have what's called *catch light*. It's the sparkle in a subject's eyes. The catch light here is created by an open door, while the catch light in the other photographs is created by a flash. You can also create catch light with a reflector.

Hey, check out the picture of a bride opening a door earlier in this chapter (p. 57). Yep! It's the catch light in her eyes that boosts the energy and excitement of the photograph. Look for catch light or create it often.

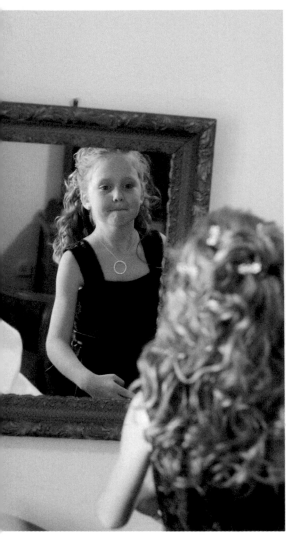
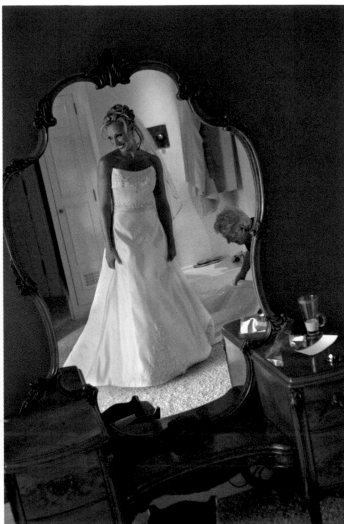

# Make the Most of Mirrors

Sure, they're a bit cliché, but mirror shots are winners when it comes to the kind of photographs that sell. So make a point of scouting out mirrors as soon as you walk into the bride's house.

Look for even lighting and nice settings. Look, too, for background and foreground elements that might be distracting or could complement a photograph. Move around to find the best possible angle, because it may not be your first choice. It's usually worth the time it takes to explore your options.

Oh yeah, one more important tip here. Make sure the mirror in your photograph is clean and does not have any finger marks or smudges on it. If it does, wipe it clean before you shoot.

# Photograph What's Important to the Bride

Most brides envision their wedding photographs as they plan the event, and all certainly have priorities. Find out what they are.

In the meantime, you can assume that shoes are important to a bride—and to the bridesmaids. So take the time to photograph the shoes that each of these women carefully selected for this occasion, and do it as thoughtfully as you photograph other important subjects on the wedding day.

No real technical photo tip here …just a philosophical one: Know the importance of photographing what the bride likes. And since few of even the best photographers can read minds, be sure to ask her what she likes before the event.

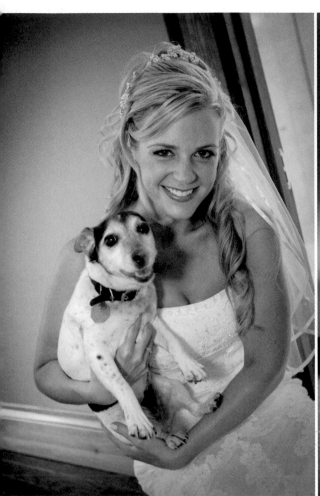 

# Here Doggie Doggie

Many brides have pets—often dogs … with "member of the family" status. So be sure to take at least two shots that include Fido: one of the bride with her pet and a portrait.

When photographing pets, you need to watch out for *pet eye*. This is the animal equivalent of red eye in people photography. You can reduce the pet-eye effect by holding or otherwise positioning your flash off camera, as illustrated by the picture on the left. You could also shoot a natural-light picture, like the photograph on the right.

Either way, just know that the pet picture will likely be a favorite of the bride.

# Create an Intimate Portrait

When you photograph a person, the closer you are to him/ her, the more personal and intimate the picture becomes. That's why many wedding photographers like to shoot close to their subjects when possible, often using a 24-70mm zoom or 50mm f/2.8 lens.

Similarly, if you shoot at eye level, viewers will relate more to your subject than if you shoot above or below eye level.

Compare these two pictures. Considering the aforementioned points, you can see why the picture on the right is more intimate than the picture on the left.

And getting back to the 50mm f/1.2 lens ... Wedding photographers love it for two reasons. The first: It lets you shoot in low light at shutter speeds that allow for hand-held photography without requiring a dramatic ISO boost. Secondly, at the wide apertures, the background is blown out of focus, which draws attention directly to the subject.

If you are serious about portraiture, get that lens—or another fast 50mm lens.

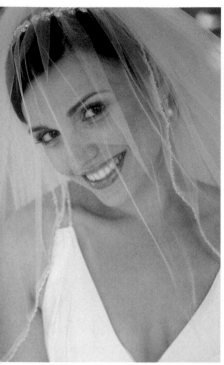 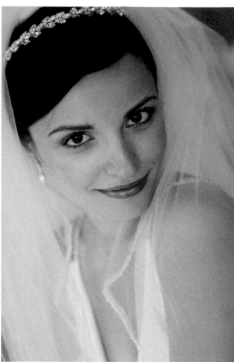 

# The Head-and-Shoulders Shot

You can be as creative as you like on the wedding day, but make sure you go for the shot that the groom is likely to cherish most: a head-and-shoulders shot of the bride. This is a photograph he will keep in his wallet, frame for his desk or tape to the top of the lunchbox he takes to a job site.

Photograph the bride veiled and unveiled. Take natural-light images for a soft look (as shown in the image on the right) and flash shots for super crisp images with enhanced sharpness, contrast and color. Just remember to shoot close for an intimate portrait, as suggested on the previous page.

Show the bride a shot on your camera's monitor from time to time to make sure she likes what she is doing. Also be sure to talk to the bride during the photo session. It will help her feel— and look—more relaxed and natural.

Finally, remember the adage: The camera looks both ways. This means that when you photograph a person, you reveal an image of yourself. In other words, your mood, energy and emotions are reflected on your subject's face. So, as a photographer, you function as a living mirror.

 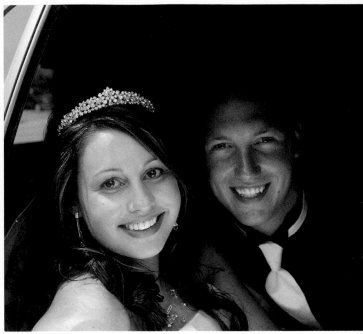

## Getting the Standard Limo Shots

Okay. So you've left the bride's house and have arrived at the wedding site. Now all you have to do is wait for the bride to arrive in her limo, so you can get the standard bride-in-limo shot.

You'll use the same techniques for the bride-and-groom-in-limo shot after the wedding.

The bride arrives, and you have just a few seconds to get the shot—which you can't miss because it's on your shot list. Here are several techniques you can use to capture that moment.

Have the bride lean as close as possible to the open door or window, so she is not hidden in the shadows. Then, shoot tight to eliminate the outside of the car and the surrounding area, which is much brighter and would be grossly overexposed when the exposure is set for the bride. Set the exposure by zooming in on the bride, locking the exposure and then zooming out.

When working with an assistant, ask him or her hold a reflector to bounce light onto the bride, who is basically in the shade. Then, finally, use a flash for what's called fill-flash photography. This is discussed in more detail on the next page.

Be mindful of the bride's time and ask her to "hold it" for just a few shots. Shoot quickly and then get the heck out of her way.

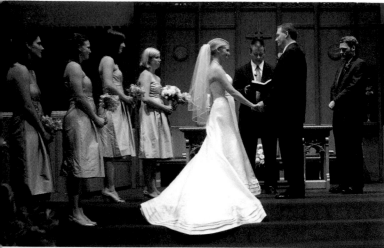

# Master Fill Flash

All these photographs are flash shots. However, they don't have the signature harsh shadows of typical flash photographs, because light from the flash is balanced with available light.

Achieving this takes some preparation. Before the wedding actually starts, put your camera on manual-exposure mode and set the exposure for existing lighting conditions. Take a shot and test your exposure. Then turn on your flash and set it to TTL, which stands for "through the lens" (or automatic exposure).

Start by setting the exposure compensation to –1 to avoid blasting the subject with light. Then, if the subject is too dark, increase the exposure from the –1 setting; if the subject is too light, decrease the exposure from –1.

Now, that may sound like a lot of work, but if you master this technique, you can make the adjustments…well, in a flash.

Another option is to set your camera on the Av mode and your flash on TTL—and hope for the best. You may get some good shots, but the fill-flash technique will give you much more control over your exposure.

When using this technique, you control the subject's illumination with your f-stop and the background illumination with your shutter speed—independently.

Note that a diffuser on the flash softens the light for an even more natural-looking picture. Using a diffuser means you lose some of the flash's power.

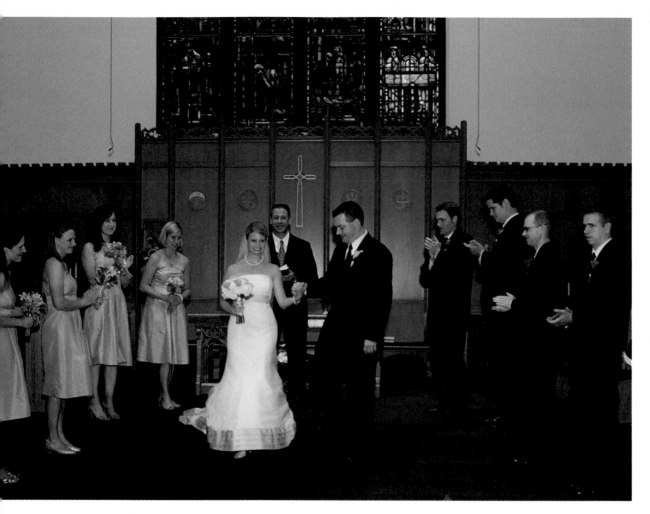

# Direct Flash

On the previous page we talked about fill flash, and how, when properly adjusted, it eliminates the harsh shadows associated with direct-flash photography. Well, pictured here is an example of direct-flash shooting.

Moving on...

Did you know you can increase the flash range (distance) of your flash? It's easy. As you increase the ISO setting, you make the sensor more responsive to light, including the effective light from your flash. Therefore, if the maximum range of your flash is, say, 20 feet at ISO 100, then boosting the ISO to 200 or 400 will increase that flash range to maybe 30 or 40 feet.

Knowing that you can increase the flash range is also important when you are bouncing light from the flash off a ceiling for more diffused light, as this increases the flash-to-subject distance.

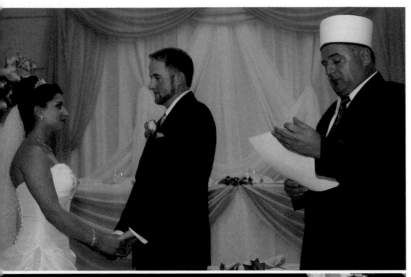

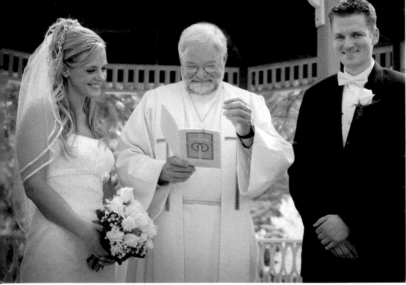

# Respect the Subjects and Situation

Before the service, always ask the following questions of the wedding officiator: May I use a flash? How close can I get? And how can I minimize disruptions?

You will find that asking these questions helps to build rapport with the wedding officiator. It also helps you plan shots and remain as unobtrusive as possible. Remember, the guests are there to see the ceremony—not you running around taking pictures.

Whenever possible, take natural-light photographs. Boost your ISO up so you can get hand-held shots. Sure, in low light, out-of-the-camera pictures may have a bit of digital noise, but would you rather have a picture with some digital noise or a shaky shot? You can always reduce the noise in the digital darkroom, if so desired.

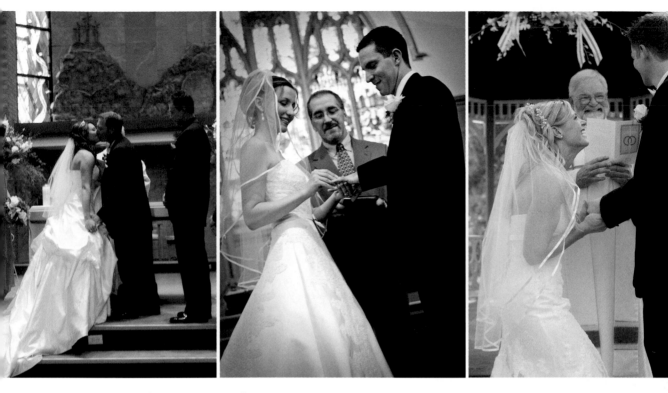

## Capture the Key Shots

Earlier, we talked about the importance of making a shot list, for yourself and the couple. Well, during the wedding, you can't miss the agreed-upon shots—two of which are always the exchange of rings and the first kiss.

Simply put, you have to get into position to get these shots. You also must have your camera set up so that your work basically becomes point-and-shoot photography. There is just no time here to experiment with camera settings.

Another thing to consider, at this and other important times during a wedding, is that you may be competing with other photographers and videographers for the best shooting positions. Be aware of your "competition" and get to the right spots first.

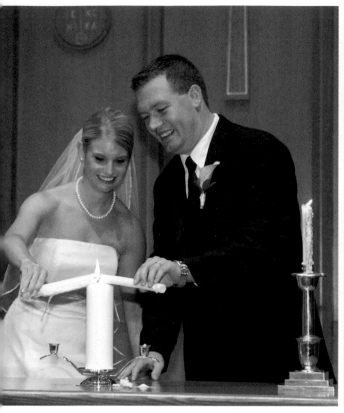 

# Tell the Whole Story

When you cover a wedding, try to "tell the whole story." Keep that phrase in mind throughout the event and you'll end up with a collection of photographs that, indeed, tell the whole story of the wedding day.

One technique for telling the whole story is to shoot both wide-angle and telephoto pictures as well as close ups, as you have seen throughout this book.

Taking candid and posed photographs is another. Be sure to photograph from standard shooting positions as well as from creative angles. You don't want to end up with a bunch of pictures that all look the same. That's boring.

# Look for Creative Angles

Beginner photographers take most of their pictures while standing straight up. Ho Hum! Try to vary your shooting positions and angles for pictures that not every photographer would take.

For the picture on the left, the camera was set on the floor, and the self-timer was activated to get a shot that the bride and groom loved. They loved the architecture of the church, which is why they selected it.

For the picture on the right, a zoom lens was set to a wide view and a wide f-stop (f/4.5 or f/5.6) was selected. That produced an image in which the flowers are in sharp focus while the background is blurred.

You will be under a lot of pressure on the wedding day to get the standard shots, but think creatively and you'll get shots that really spice up a wedding album.

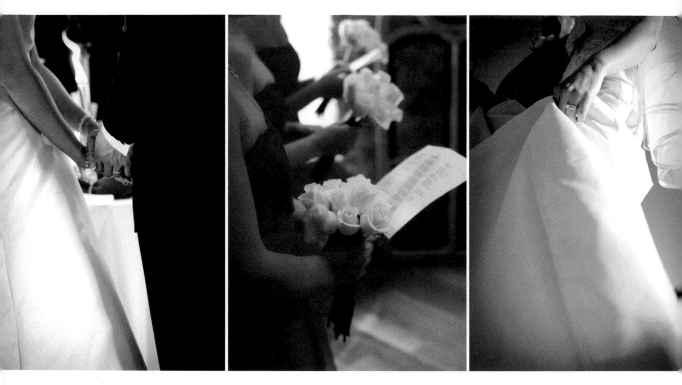

# Don't Overlook the Details

Here are some detail shots. These are not tight micro-type shots, but they do show some important details of the wedding: hands, ring, flowers and the wedding ring.

The point here is that you can focus on capturing the details even when you are shooting with a wide-angle lens or with your zoom set to a wide-angle.

When you shoot a wedding, try to envision how a movie director would cover the event. This would include cutting to close-ups like the scenes you see here.

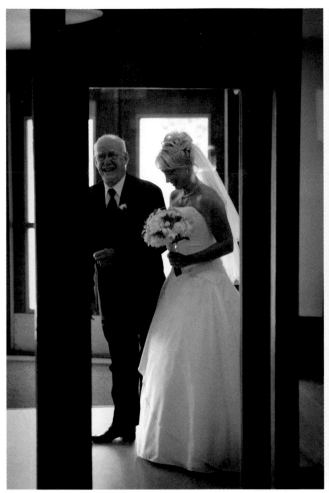
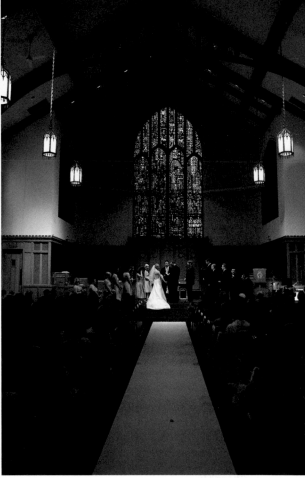

# Frame Your Subjects

We see the world in three dimensions: height, width and depth. Cameras see only two: height and width. Therefore, part of a photographer's job is to create a sense of depth in the pictures (s)he creates.

Framing the subjects can do that. In the picture on the left, the bride and her father are framed with a glass door. On the right, the bride and groom are framed with the pews and ceiling lights.

Shadows also create a sense of depth in a picture, as do foreground elements. Take advantage of them whenever possible.

When you shoot, try to see in three dimensions to create a picture with spatial depth. Sure, it is not always possible, but thinking that way helps you avoid an album full of flat pictures.

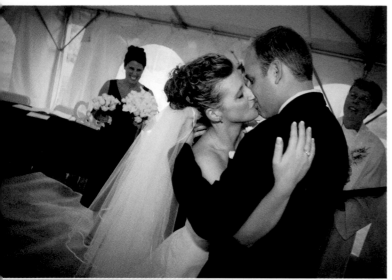

# Use the Disequilibrium Effect

Two simple techniques for making a picture more interesting are 1) placing the subject off center, and 2) tilting your camera down to the left or right for what's called the *disequilibrium effect.*

Placing the subject off center makes for an interesting picture because the viewer looks for other components in the scene. Similarly, tilting the camera sets the viewer's visual balance off center and encourages him or her to examine the image more closely.

Like all techniques, if you overuse these, your pictures will look the same. It's a good idea to use several techniques for key shots and then let the couple choose which version they like best.

# Master the Art of Walking Backward

This is not a photography technique tip. Rather, it's important advice about being a wedding photographer.

In addition to all the other things you must master, it's important to master the art of walking (sometimes running) backward, especially as the bride or the bride and groom walk toward you.

You can practice this technique, with your camera in hand, in your house and in your driveway.

On site, from time to time, you must remember to look behind you to make sure you do not bump into someone, knock into a pew or worse.

Working with an assistant makes the art of working backward easier. (S)he can walk behind you with a hand on your shoulder to guide you along.

Master this ancient art form (ha ha) and you will not miss shots like this.

# Compress the Brightness Range

Our eyes can see a dynamic range of about 11 f-stops. Our digital SLR sees five or six. Therefore, in many situations we need to compress that brightness range to avoid a picture with overexposed highlights or blocked-up shadows, which show little or no detail. Controlling light also helps you avoid spending a lot of time in the digital darkroom trying to salvage an important picture.

Noticing and then controlling the light as much as possible is an important part of being a wedding photographer—and a photographer in general. You can reduce the dynamic range (the contrast range) by using a reflector, a diffuser or a flash … or by positioning the subjects in the shade.

In camera, a good way to avoid poor exposure is to check your histogram, which you should do religiously. When you see a spike on the right, it means your highlights will be washed out; when you see a spike on the left, it means your shadows will be blocked up. In both cases, you can quickly and easily adjust your exposure with the +/− exposure control.

If, however, you end up with overexposed highlights and underexposed shadows, you can try fixing it in the digital darkroom with the Shadow/ Highlight adjustment. This tool is available in Photoshop, Photoshop Elements, Adobe Photoshop Lightroom and Apple Aperture.

# Separate the Subjects

Earlier in this chapter we talked about seeing the world in three dimensions. That's especially important when photographing groups. Because pictures are flat, lacking real depth, we need to separate subjects so they don't blend together.

The top picture has an added sense of depth and separation because the groom is closer, by about six feet, to the camera than his friend in the middle. Note that for the top shot you must use an aperture that gets not only the groom in focus, but also his groomsmen. A lot has been said of using f/1.4 or f/2.8, and while those are great settings for creating separation by blurring the background, used here they will result in a groom in focus with four blurry friends.

In the bottom photograph, there is enough separation between the subjects' heads that they all stand out prominently. This underscores the importance of positioning your subjects well.

Don't overlook the importance of thinking and seeing in 3D. It's why it's mentioned here more than once … wink.

# Outdoor Weddings

Pray. That's my best advice for covering an outdoor wedding.

*For what am I praying*, you might ask. Good weather, of course!

Good wedding weather, as far as most wedding photographers are concerned, is a slightly overcast sky during the ceremony and reception. When the sky is overcast, the light is perfect for people pictures, because the light is diffused. In this situation, you don't have to worry about harsh shadows from direct sunlight ruining your pictures. This also means you don't need to use a flash, reflectors and/ or diffusers to reduce the contrast range we addressed a few pages back.

If your overcast-sky pictures look a bit flat, you can easily enhance them in the digital darkroom by boosting the contrast and increasing the color saturation. Here is a neat trick to brighten dull photographs: Nik Software (www.niksoftware.com) has a cool plug-in called Color Efex Pro that features a sunshine filter. This does a nice job of brightening flat pictures.

As long as you are praying (or at least hoping) for good weather, include a request for the sky to clear up so you can shoot a spectacular sunset. There is no better way to end a wedding album than with a photograph of the bride and groom silhouetted at sunset.

# Take Advantage of the Situation

Hey, shooting on an overcast day is nice; but when it rains, that's a different story. You can actually take advantage of the situation though and use umbrellas as props for fun shots, as illustrated by these pictures.

When a subject is under an umbrella, (s)he is darker than the surrounding area. Therefore, you usually need to use a flash for what's called fill-flash photography, as illustrated in the top picture. Otherwise, you may want to increase the exposure by half an f-stop, as shown in the bottom picture.

If you forget to use these techniques, try using Photoshop's Shadows/Highlights tool (which lets you adjust the shadows and highlights independently) in the digital darkroom to open the shadow areas. It works quite well if the subjects are not underexposed by more than an f-stop.

Whatever technique you use, keep in mind that you, and your clients, usually want to see faces in a photograph.

As far as your camera is concerned, you must protect it from the elements. Rain covers are available in camera stores, and they will protect your camera while still offering full access to its control and function.

One more thing: Rain is actually considered good luck on a wedding day… or so they say.

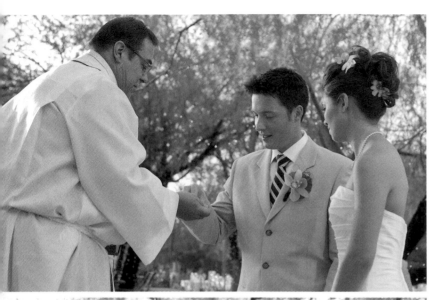

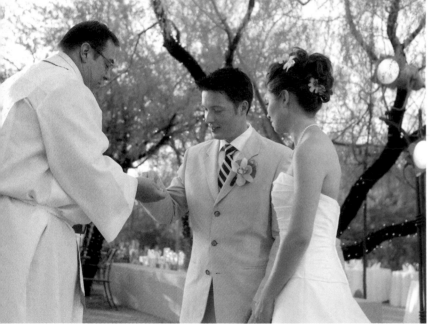

# Watch and Fix the Background

Check out the bottom photograph. It looks as though the groom has horns growing out of his head. Davide took this shot to illustrate the importance of watching the background.

Simply put, the background can make or break a photograph. That's why it's important pay special attention to background elements. Sometimes, avoiding bad background elements is impossible. That's where Photoshop Clone Stamp comes in; it enables you to remove those bad background elements, as illustrated in the top photograph.

In camera, you can reduce or eliminate bad background elements by using a telephoto lens set at a wide aperture to blur the background.

Speaking of the background: Be especially mindful of it at the reception. "Uncle Buddy"—standing in the background after having a few too many drinks with his shirt open—could ruin a beautiful shot of the bride and groom's first dance.

# Zoom-Lens Advantage

Flexibility. That is the name of the game when it comes to wedding photography. You must be flexible when it comes to just about every part of it—including how close you get to the subjects and how much … or how little … of the frame you fill.

Zoom lenses give you flexibility. Zoom with your feet … and you become even more flexible!

A versatile zoom lens for wedding photography is the Canon 24-70mm f/2.8L lens. In addition to helping you get everything from headshots to full-length shots, it's super sharp and relatively fast (so you can take hand-held natural-light photographs in relatively low-light conditions).

Another versatile zoom is the Canon 70-200mm f/2.8 lens. It lets you get close shots even when the camera-to-subject distance is too great for a 24-70mm lens.

# Before the Cake is Cut

Wedding cakes are an important part of the wedding tradition, and they're an important part of wedding photographs. They may not make it into the final wedding album, but it's a sure bet that the bride and groom (okay, at least the bride) wants the shot.

Fortunately, these are easy shots to take and they're appropriate for some of the lighting and composing techniques previously discussed. One thing to keep in mind is that you want accurate color in your wedding cake photographs, as opposed to nice color. Therefore, set your white balance to existing lighting conditions before you take these shots.

And be sure to photograph the cake from different angles so that you please the bride.

The main tip here, from a non-photographic standpoint, is to get the shots before the cake is cut. It's actually one of the first shots you should take when you arrive at the reception.

# Combining Techniques

Wedding photography, as with all types of photography, is most successful when several techniques are used to create a pleasing array of pictures. The techniques we've described include balancing light from the flash to available light, positioning subjects with adequate separation, using the disequilibrium effect, lighting a subject's face, considering the background and capturing a special moment.

If you had to refer to a checklist of all these techniques before you click, you'd miss the shot.

I like this next analogy about how a good photographer combines techniques: "Being a good photographer is like being a good jazz musician. The jazz player does not think about what note he just played, what note he is playing and what note he'll play next; he just does it. He feels it. The same is true for a good photographer. It just has to happen naturally. That's when the true magic of photography happens—when it's not work and becomes fun."

# Group Shots

The reception is a great time and place to take group photographs. But plan ahead and "warn" the wedding party—which usually can't wait to start the party, especially if it's cocktail hour—that you want to take some pictures at the reception site soon upon arrival. That way, you'll get a nice formal group shot like the top photograph here.

Sometime during the reception, ask to take the shot again … maybe with a smaller or larger group. This shot will capture some of the fun the bride and groom and their guests have at the reception.

From a technical standpoint, this pair of photographs illustrates two different flash techniques. For the top photograph, light from the flash was bounced off the ceiling for soft, flattering lighting. For the bottom photograph, direct flash was used. Whenever possible, go for softer illumination of people.

# Getting a Good Flash Exposure

No matter how much fun you are having at the reception (because most of the pressure is off at this point), it's still important to get the best possible in-camera flash exposures. To do this, you must know how a flash works.

Basically, when a flash fires, light travels to the subject and then bounces back through the lens and onto the image sensor. This is how *through-the-lens flash metering* came to be named.

So if a subject does not fill the frame, as in these two examples, light from the flash may travel past him/ her and attempt to illuminate the background, which may result in an overexposed subject. If this happens, simply reduce the flash exposure (either on the flash or in camera) until you get a good exposure.

Some cameras let you lock the flash to the focus point. And that sure makes things easy when it comes to on-the-move flash photography. So if you are looking for a new camera for wedding photography work, find one with that feature.

 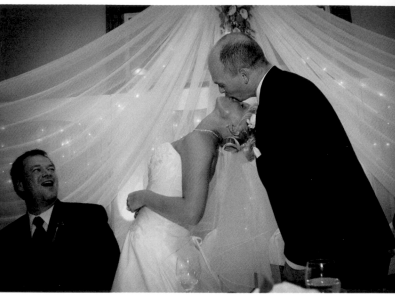

# Envision the End Result

When you see a potential photograph, ask yourself a question: What do I like about the scene and what don't I like? This will help you think like a painter. Let me explain.

A painter looks at a scene and considers its translation to a blank canvass. (S)he decides what elements to include and what to omit in the painting. On the other hand, a photographer looks at a scene, but does not always have the luxury of excluding elements that are distracting or awkward.

Sometimes, of course, changing positions or using a long lens set to a wide aperture can blur the background and help create an appealing artistic image, but sometimes photographers have no choice other than to shoot what's actually in front of them.

That's where Photoshop and other digital image-editing programs come in. In the Photoshop section of this book, you'll find examples of how to blur a distracting background. You'll also see how effective it can be to crop out unwanted elements in a scene.

When you shoot, always keep in mind the end result and remember how quickly and easily a photograph can be improved, as shown in this cropped picture.

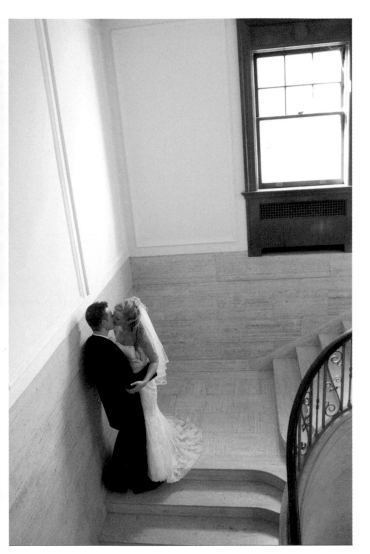

# Environmental Portraits

Basically, there are two types of portraits: headshots, which show the subject cropped tight, and environmental portraits, which show the subject in context of a full setting.

Most wedding couples prefer the close-up type of portrait, but it's a good idea to take environmental portraits, too, like the one you see here. They add variety to the wedding album. What's more, environmental portraits have a greater sense of place than a tight headshot, which could have been taken in a studio, at the reception or on a cruise ship.

For environmental portraits, you want to use a wide-angle lens set at a relatively small f-stop so that most of the scene is in sharp focus.

Speaking of focus, one technique for focusing an environmental shot is to use a wide-angle lens, select a small f-stop, set the focus one-third into the scene, lock the focus with your camera's focus lock, and then reposition and shoot.

# Don't Forget the Kids

These are two fun shots of kids at weddings.

To get shots like these, make sure your camera is all set for a good exposure and then get down to their level, seeing the kids eye-to-eye. Say something funny or tell a joke … and shoot fast.

If you miss the shot on the first or second take, move on and return later for another quick shoot. Don't overstay your welcome on a first encounter, or else the kids may begin to feel self-conscious and won't cooperate (which I can totally understand, being a kid at heart myself).

Here, too, zoom lens offers the advantage of quick framing for on-the-go photography.

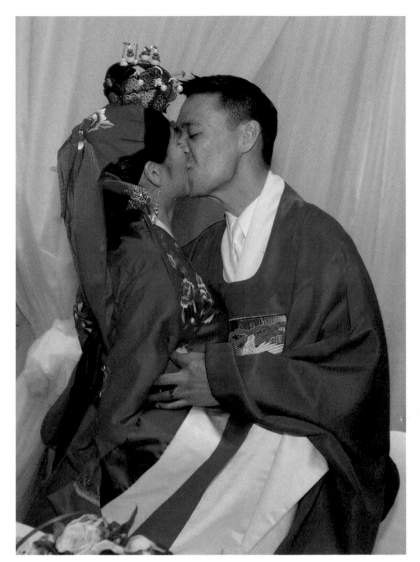

# Don't Rush Off

Hey, it's been a loooong day, and you are tired. You worked your butt off to get great shots for the bride and groom as well as their parents. And you may think you've put in your time and more, even if the reception is not over. You figure it's time for you to go home and download your images.

Don't leave. Stick around for an extra hour or so.

Not only might you get some unexpected shots, but the folks who hired you will know that you really care and want to do the best possible job.

For that reason alone, hanging out a bit longer than expected may get you unexpected new jobs.

# Shoot a Sequence

You know the old saying, "Every picture tells a story." Well, that's true. It's also true that the more pictures you have, the more of a story you tell. That's why it's important to shoot sequences. Sure, not all of the sequence shots end up in the wedding album, but brides and grooms love them and often send some of the official "outtakes" to family and friends.

Shooting a story sequence is really only a matter of deciding what you want to say and then capturing enough moments to say it. Usually, three or four pictures is adequate.

This is one of my favorite sequences. It tells the story of a person drawing a heart in the sand—from start to finish.

If you have Photoshop, you can combine your sequence into a single image (as shown). Just increase the canvas size of one image (Image > Canvas Size) and then drop your other pictures into that file.

Three-in-one images like this are fun to create and give you yet another type of innovative photograph to sell.

# Working with Reflectors

Compare these two photographs. In the picture on the left, the bride's face is beautifully illuminated, and we can clearly see her eyes. On the right, the bride's face is darker and looks a bit flat. The difference is that an assistant held a reflector off-camera to bounce sunlight onto the bride's face when shooting the picture on the left. No reflector was used for the image on the right.

Reflectors come in all sizes and shapes and usually have a gold side and silver side.

Want a portable and affordable reflector/ diffuser kit? Check out Rick Sammon's Portable Lighting Controller and Tote. It's described on the Bio page of www.ricksammon.com.

Because you will be shooting outdoors on occasion, never go on a job without a reflector and diffuser. Both compress the brightness range in a scene, thereby making it easier for you to get a good exposure.

# Using Fill Flash Creatively

Fill flash was covered earlier and as explained then, the basic concept of this technique is to balance light from the flash to available light. This helps you avoid ending up with a picture that looks like a flash picture … with its hallmark harsh shadows. Check out that tip on page 68 before you read on.

Now, you can take that process to the next step for even more creative control.

Compare these two images. You can see that the background is darker in the left image, but the faces of the bride and groom are illuminated the same in both. Here's how you achieve this.

First, set your camera to manual exposure control and dial in the correct exposure. Now, reduce that exposure by one f-stop. If you take the shot now, the background will be darker and the colors will be more saturated than if you hadn't reduced the f-stop.

Next, turn on your flash and set it to TTL (automatic). Use your +/– flash exposure-compensation feature to dial in the correct exposure for your subjects.

The idea is that the flash illuminates the subjects, which you control with the f-stop, and you control the brightness of the background with your shutter speed.

How cool is that?! All with a single flash.

So full disclosure: This example was actually created in Photoshop, because we didn't have an example on hand to illustrate this technique. Knowing that, try to create this effect in Photoshop, too, by simply darkening the background. It will make your subjects stand out more prominently in the scene.

 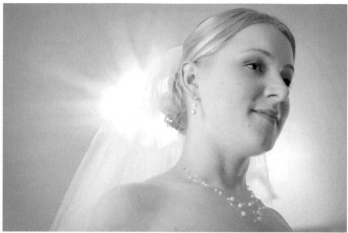 

# Take Advantage of Lens Flare

Lens flare, which can make a picture look flat and create streaks in an image, occurs when direct light—from the sun or a light—falls on the front element of your lens (or the filter). To avoid lens flare, use a lens hood.

Lens flare, however, is not always a bad thing. In fact, some photographers use it for a creative effect, as illustrated in the picture on the left and in the center.

But the effect of lens flare in a photograph is as unpredictable as a bride's emotions on her wedding day. So you have to play with the effect, shooting without a lens hood toward the sun, to see if you like the lens flare in your photograph. An example is illustrated in the picture on the right. There's a strange-looking streak, and the image looks a bit flat. Even so, the couple liked the picture and included it in their wedding album—technical imperfections and all.

Here's another tip on lens flare. The f-stop at which you shoot affects the effect of lens flare. Small f-stops produce sharper beams of flare, as illustrated in the center image. Vary your f-stop to fine-tune the effect. Keep in mind that varying the f-stop will also cause other elements of the image to be either in focus or blurred since you are changing the depth of field.

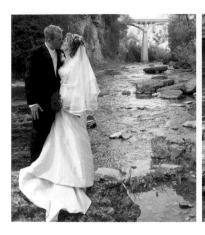  

# Look for Pictures within Pictures

The center picture is the original, full-frame shot. The couple liked it. However, it's always good to look for pictures within pictures; it's how we got the images on the left and right.

After the shoot, when you're sitting at your computer listening to iTunes and editing your work, play around with the crop tool. Try to create new pictures from your originals.

One reason to shoot RAW files at the lowest possible ISO setting is that you get cleaner—and more—data to work with than if you shoot JPEGs.

But if you see a picture within a picture and don't have a high enough resolution to make it a print, upsize the file using Genuine Fractals, a Photoshop plug-in from onOne Software (www.ononesoftware.com).

# What is a Good Exposure?

I bet you know where to get the best slice of pizza—and no doubt the best pizza ever made! Well guess what? I know where to get the best slice of pizza, too…as do all the readers of this book.

My point: The best slice of pizza is a very personal thing … just like an exposure. Some photographers like slightly darker images; others like photographs that are slightly lighter than "perfect." The same is true for wedding couples.

The top couple prefers bright images, and the couple in the bottom image likes slightly darker, moody images.

Make sure you talk with your client couple about the type of pictures they prefer—before their big day. This will spare you the time and effort it takes to batch process a ton of shots to change the exposure … after you think all is said and done.

# Choose a Creative Background

Cool or boring? The choice is yours when it comes to choosing a background for a portrait.

That's it for this tip! Except … think creatively at all times!

# Indoor Fill Flash

Flip back to page 59—the Create a Mood tip—and check out the pictures of the bride coming down the stairs. Then come back here.

Okay, as you saw in those pictures, the window was overexposed and washed out. Technically, that may not make for a perfect exposure, but it created a dreamy effect. And it was a success, according to the bride. She loved this photograph.

Here, the photographer wanted to create a more realistic image. Therefore, he used a proper exposure to capture both the couple and the area outside the window.

Fill flash is covered earlier, and this is just another example of how important it is to master this technique. With it, you can have fun creating pictures that will definitely make it into the wedding album.

# Fun Group vs. Posed Group Shots

Compare these pictures. Which one has more life?

Which type of picture brings back the fun of the moment?

Which one looks more natural?

Which one suggests that the photographer is fun to work with?

Which one is more creative?

Which one has a better background?

That's enough questions for now. Your answers will tell you which type of shot you simply can't miss.

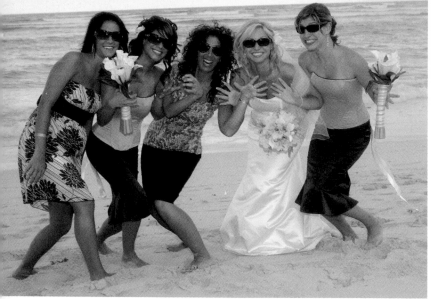

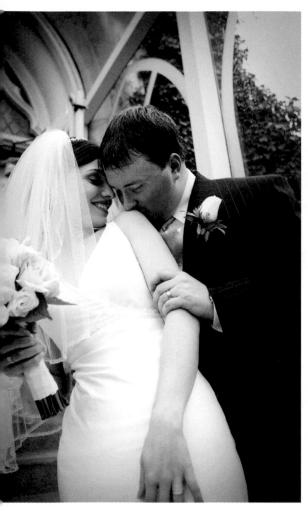

# Capture Fleeting Moments

One thing we haven't yet covered is shutter speed and how to freeze the action.

When the action you're trying to capture is happening quickly, use a shutter speed of at least 1/500 of a second to freeze it. Look to capture the peak of action, as illustrated in the photograph on the left.

Also be sure to set your camera to rapid frame advance in situations like this.

When shooting RAW files for action sequences, make sure you have a fast write-speed memory card. Check your camera's instruction manual for the maximum number of pictures you can take before your camera "locks up." If your camera locks up, you may miss the most important shot in a sequence.

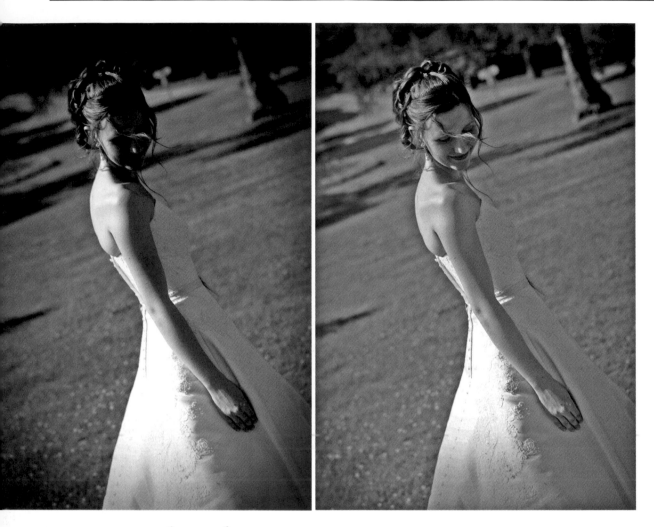

# Creative Side Lighting

We've discussed Rembrandt lighting, which is side lighting that beautifully illuminates a subject's face.

The picture on the left is an example of this type of lighting. However, the subject's face is not visible here, because she is turned away from the sidelight. This is a creative technique that photographers can use for a creative picture.

The image on the right is another example of Photoshop handiwork. Shadows/ Highlight was used to open up the shadows so the bride's face is a bit more discernible. It's included here as an example of what you can do if your client does not fully appreciate your creativity.

# Create a Private Moment

At sometime during the wedding reception, find a nice secluded spot and take a relaxed portrait of the newlyweds. Finally, the pressure is off—for them and you!

Find a location and determine the correct exposure before summoning the newlyweds. Then move the couple into position swiftly so you can shoot and scoot. Let them get back to celebrating.

# Bend the Rules

Here is a very important tip: Bend the rules sometimes. When you do, you end up with more creative shots. Here is an example.

In the picture on the right, the couple looks great, and they are positioned somewhat in the middle of the frame. It's an okay shot. There is technically nothing wrong with it.

But now check out the picture on the left. The subjects are way off center, creating a much more dynamic photograph. What's more, the background is a bit out of focus, which is not the way we would actually see this scene in real life.

Sure, in a situation like this, you could put everything in focus by locking the focus one-third into the scene and using a smaller f-stop. That is technically the way to go. But creative photographers may want to play with the out-of-focus effect.

Whether it's this one or others, bend rules. It'll help you eventually develop a signature style for your work. Just make sure you practice your new techniques before the wedding, so you're not surprised by the results you get when it's over.

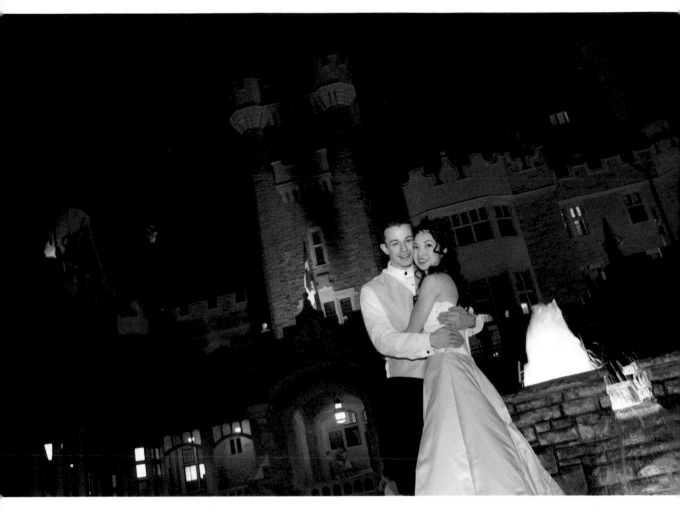

# Shooting at Night

If you've read all the tips in this chapter, you know that this is a fill-flash shot.

In mixed-lighting situations like this, when you have available light and light from your flash, set the white balance to flash for accurate skin tones. This is what you want in this situation.

When shooting fill-flash pictures at night, be sure to boost your ISO to 400, or maybe even 800, to record the background light (if you don't want to use a tripod for a steady shot at a lower ISO setting).

Speaking of tripods, they're the ball and chain of photojournalist-style photography. They drastically reduce your flexibility to cover events, which involves running from here to there and back again to capture important scenes. That said, never leave home without a tripod, as you never know when you will need it.

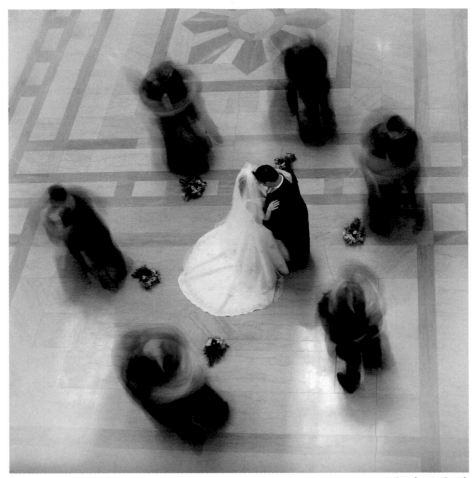

© Stephanie Smith

*Part 5*

The sign of a true professional is that a difficult job looks easy. It's another of my all-time favorite expressions.

And the pros featured in this section, including Stephanie Smith of 831 Photography … whose image you see here, do just that. They make the creative process of spectacular photography look easy.

Better yet, they share their secrets with you here, with hopes of helping you expand your creative horizons. Find their web sites at the end of the tip they provided. Check 'em out for more information.

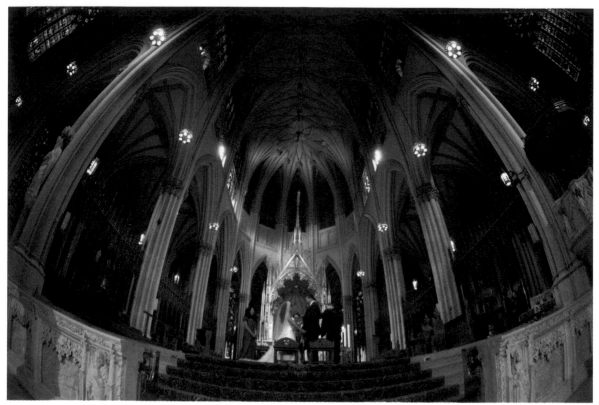

© Rocco Chilelli

# Be Nice

When you first enter a church or a temple, find out what the rules and regulations are for the place. Don't forget that you are a guest and that you can't do whatever you want. Talk with the people who are in charge before you start photographing.

When I entered St. Patrick's Cathedral in New York City, there were so many security guards around that I knew shooting conditions would be strict. In fact, before the shoot, I had learned that use of tripods during the ceremony is prohibited.

In this situation, I could have created this image by increasing the ISO and hand holding the camera, but I knew I'd be enlarging this image for the wedding album. The only way to get the quality I needed was to use a tripod.

So while I waited for the ceremony to begin, I made friends with the security guard near the altar. We started joking around and laughing. Then, when the timing was right, I asked him if I could get one shot with my tripod. For some crazy reason, he let me. I took only one shot and it resulted in this beautiful image. It really pays to be nice to people.

*Rocco Chilelli • Photographer/Nice Guy*
*Camelot Photography Studios, Inc. • www.camelotstudios.com*

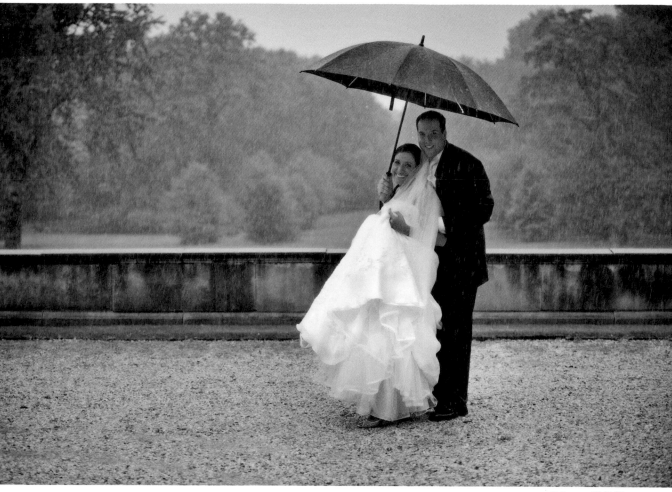

© Rocco Chilelli

# Go For It

The hurricane was going to hit. We just didn't know when. It wasn't raining when we left the wedding, but by the time we got to the reception, it was coming down in buckets. Although I had taken some photographs indoors, I was determined to get an outdoor shot.

Despite the heavy rain, I said to myself, "What the heck; let's go for it." So there I was, standing in the pouring rain with my new camera. I got three shots off before I ran for cover.

Sometimes you just have to do what you have to do to get the shot.

*Rocco Chilelli  ·  Photographer/Nice Guy Even in the Rain*
*Camelot Photography Studios, Inc.  ·  www.camelotstudios.com*

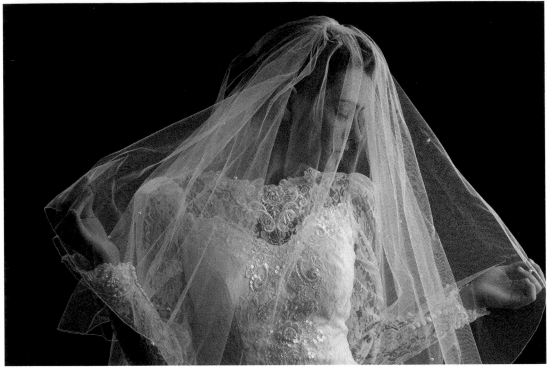

© Norman Phillips

# It's All About the Light

Everywhere I go—seminars, workshops, informal meetings—conversation inevitably hits the subject of lighting and posing. This is because, aside from the posing element of portraiture, light is the primary concern of most professional photographers. Mastering the use of light … in the studio, outdoors or in homes using window light … is the most important skill for capturing top-class images.

The books I've written include analysis of the work of more than thirty top-class photographers as well many of my own photographs. In reviewing hundreds of images for these books, I learned techniques and styles that opened my eyes to a vast array of available lighting options. Let this inspire you to take the next step in creative capture.

From my perspective, simply creating standard lighting patterns on a subject's face is sterile. Instead, think of the standard patterns as a platform for creating greater dynamics. For instance, unlike most other photographers, I love low-light situations. Thus, in situations that most of my colleagues ignore, I see beautiful opportunities.

So whether you see a photograph as great, good or awful, let it teach you something. Identifying the strengths and weaknesses of images is a valuable part of the learning process. Taking the time to do this type of analysis will make you a much better photographer. See the light!

*Norman Phillips • Photographer and author of nine books • www.normanphillipsseminars.com*

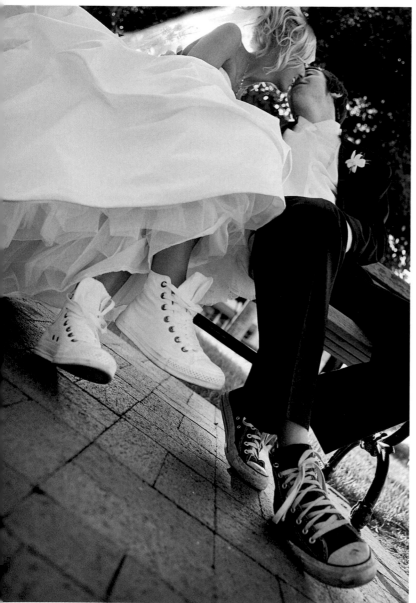

© Scott Plauché

# The Little Things Really Do Matter

I'm often asked, "How do you get couples to look so relaxed and into each other in your photographs?"

It's easier than you think.

Too often photographers put enormous pressure on themselves to make "magic moments" happen. The funny thing about that is, they happen naturally. You can capture—and enhance—them by paying attention to the little things and applying your photographic experience.

The little things matter so much. The way a couple holds hands with just one or two fingers … how they stand together when they think no one is looking … the expression on her face when he gives her a little kiss … These are the things that matter.

So my best answer to that question is that I let couples be themselves and capture it (as shown in this image).

Remember that wedding images aren't about a photographer; they're about the couple … and the people and things they love. Get to know the bride and groom prior to the wedding day.

Then, when shooting, know when to be quiet and when to give direction. Watching and listening to the couple is often the best thing you can do as a wedding photographer.

*Scott Plauché • Photographer, Workshop Leader • www.scottplauche.com*

© Stephanie Smith

# Make Your Vision a Reality

Being a photojournalist, I rarely setup images. However, when a vision strikes me, I make sure to make it happen.

When the bride and groom in this photograph told me they were going to do pictures in the courthouse, this image immediately came into my mind. I knew I had to make it happen.

The courthouse has an amazing marble floor, and there's a balcony that circles the main hall. I envisioned the bride and groom just holding each other while their bridal party danced around them. I had no doubt that this location was the best place to make it happen, because I would be able to position myself almost directly above them.

I set up the camera on a tripod, which has an extending arm that allows the camera to point straight down. Once the camera was in place, I asked my "dancers" to spin on the spot, fairly quickly. The bride and groom held completely still.

I counted down, the dancers started spinning and then ... using a remote shutter release... I opened the shutter for 1.3 seconds on my Canon 40D. It was set on a Bogen/ Manfrotto tripod with a ballhead. This was the result!

*Stephanie Smith • Photographer • 831 Photography*
*www.831Photography.com • www.831PhotoCouture.com*

## Work Into the Night

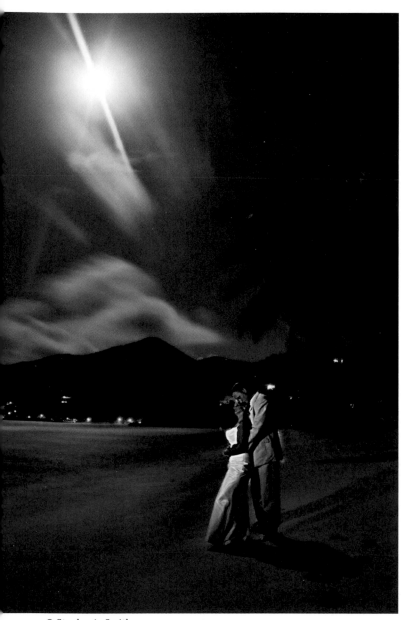

© Stephanie Smith

While covering weddings, especially destination weddings, I love to capture the bride and groom in context of the site's mood.

So I don't stop when the sun sets. Instead, I go out late at night and capture the after-hours mood. I take my tripod and play with long exposures and painting with light. (See page 36 for information on this technique.) This enables me to unlock the amazing beauty of the scene with my client.

For this image, I set my Canon 1D Mark III for a 30-second exposure to capture the movement of the clouds over the mountain. Of course I used a tripod, my Bogen/ Manfrotto with a ballhead. The full moon illuminated most of the scene for me, but I used a small flashlight to paint light onto my clients so that they were more than silhouettes.

I simply asked the bride and groom to hold still and then I went to town creating the image I saw in my mind's eye.

My advice is to take your time and play with night photography. Sometimes the most amazing images happen after dark.

*Stephanie Smith*
*Photographer*
*831 Photography*
*www.831Photography.com*
*www.831PhotoCouture.com*

© Shannon Smith

# Master Low-Light Photography

*Low light, fast action and no flash allowed—* the nightmares of photographers everywhere. Yet not only are these challenges common for weddings, they are often celebrated. Candlelight ceremony, anyone?

While you may have few options as far as the lighting is concerned, you can still capture great images without having to re-stage the scene. Here are some quick tips.

1. Prime lenses are your friend. A prime lens is your best tool for low-light photography. Ranging anywhere from one to five stops faster than their zoom counterparts, the speed of a prime lens gives you a huge advantage in low-light situations.

2. Use ISO to the extreme. Digital noise on most SLR cameras is well-controlled, especially compared to what was available just five short years ago. Add in the increased resolution, which results in a finer noise structure, and prints made from ISO 1600 images today can easily compete with ISO 200 images from cameras just three years ago. If noise becomes too much of an issue, you can always print the image in black and white; the difference is astounding. But it's better to have a noisy image than no image.

3. Consider high-speed drive shooting. You may not have thought that shooting higher FPS would help get you sharper images, but this is probably the best-kept secret of wedding photographers. No matter how carefully you squeeze your shutter, there will be some movement of your camera.

Shooting in bursts allows you to capture two or three images in succession, which gives your body a chance to settle down from the movement. Generally, I can shoot at much slower shutter speeds with this method—up to two stops slower than normal! Imagine using a 1/50 second shutter with a 200mm lens…without a tripod or optical stabilization. With high-speed drive mode, it's truly possible!

Mastering low-light photography is the key to good wedding photography. With practice, the right equipment and a little knowledge, you'll be able to capture images in practically any situation.

*Shannon Smith • co-owner of 831 Photography, workshop leader and lecturer*
*www.831Photography.com • www.831PhotoCouture.com • 831photo-Shannon.blogspot.com*

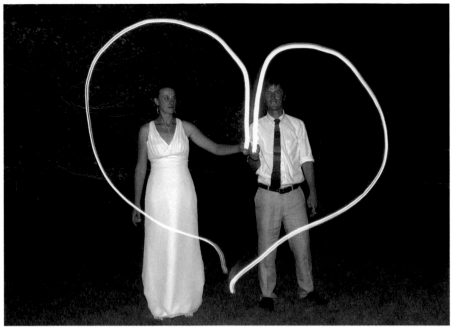

© Dan Wagner

# Shoot with Your Heart

I love incorporating shapes and interesting lighting in my photographs. This photograph of Jill and Sean making a heart with flashlights on their wedding day allowed me to do both. Best of all, it turned the creative process into a collaborative experience.

My inspiration came from *Life Magazine* photographer Gjon Mili's famous portrait of Picasso drawing a minotaur with a flashlight.

Here's the recipe for photographers wishing to explore this technique:

1. Select a dark location with minimal ambient light.
2. Place your camera on a tripod and attach a cable release.
3. Set the shutter speed to B (bulb).
4. Choose an aperture that will provide sufficient depth-of-field for the subject.
5. Trip the shutter and fire the flash.
6. Immediately begin flashlight movement. Upon completion, close the shutter.
7. Check result and modify any of the following: ISO, speed of flashlight movement, f/stop, etc.
8. Allow your subjects to view the progress, and involve them in the process. Be sure to use your digital camera zoom-in function to check sharpness.

If you're happy with the shot and it feels right, it probably is. That's shooting with your heart.

*Dan Wagner • Photographer, teacher, artist*
*www.danwagner.com • www.danwagnerphotography.com • www.worldofwagner.com*

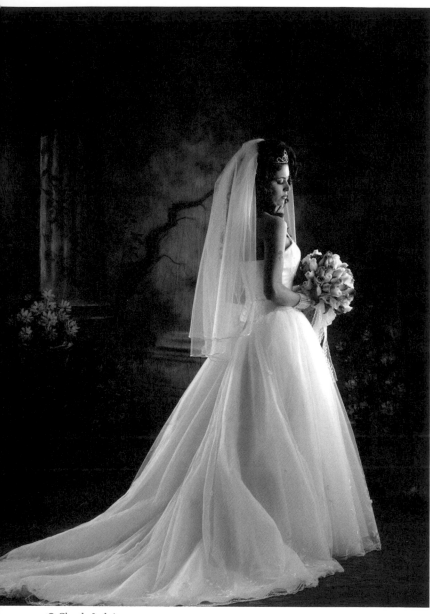

© Claude Jodoin

# Think Unconventionally

While it is, conventionally, easier to use a light background for shots like this—to remain in the same key as the subject's dress—I chose to take the opposite approach and match the background to the bride's exotic looks. Yet I wanted to avoid the stark contrast of a front-lit gown against a dark background.

This unconventional path led me to create illumination angles that would keep most of the gown in shadow, thereby rendering the white as gray, but still tonally well-modulated.

All of the light sources were placed between the subject and background. There were no lights in front of the subject, which is quite unconventional—and it resulted in one of my most popular images.

*Claude Jodoin*
*Photographer, Consultant*
*and Educator*
*www.claudejodin.com*

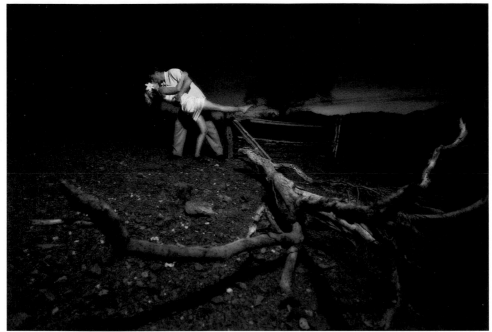

© John D. Williamson

# Scout the Location

Great shots don't just happen. You make them.

For a wedding in Arizona, the bride and groom had already selected a park for their environmental portraits site. The morning before the wedding, my assistant and I scouted the park and found several key locations. At the same time of day as the wedding shoot, we walked the selected path and stopped at each location, as if we were taking the pictures. This allowed me to see how the light would look the following day (or at least give me a really good idea).

Scouting the area of your upcoming shoot is essential for getting the best possible images, especially if you are shooting at a location you have never visited.

For this shot, I used a Westcott Spiderlite TD5 with strobes and a Lithium Ion battery pack. The TD5 had a 24x32" soft box that was located just over my camera and slightly off to the right. The light was about eight feet off the ground. I used a Canon 5D with a 16-35mm f/2.8L lens set at f/7.2 at 1/125 ISO 100.

I first set my exposure for the sunset and then added the TD5 for the subject. I had to vary the distance to get the amount of fall off that I wanted. I used all four strobes in the Spiderlite TD5, which gave me 200 W/S.

Nevertheless, it was the cooperation of the bride and groom that made this shot possible. Not every couple will hike into the dessert for two hours before their reception. Make sure you talk to your clients about their expectations for your photography work and know what they are willing to do.

*John D. Williamson · www.jfwestcott.com*

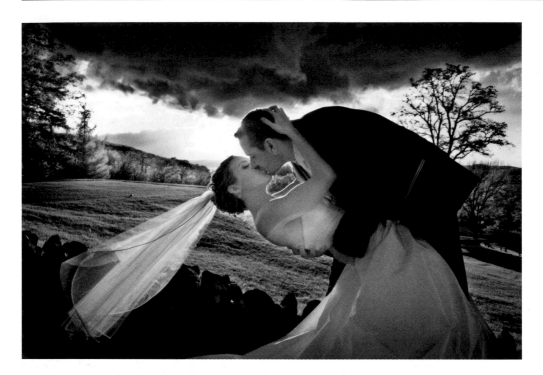

# Got IR?

When shooting weddings, it's often my goal to bring an added touch of the surreal to an already unbelievable day. Sometimes this means playing with f-stops or looking for interesting angles. Other times it means using an entirely non-traditional tool to create imagery the bride and groom have never seen before. One such tool is a DSLR that's modified to capture infrared (IR) light.

Because I'm always experimenting with new gear and cameras, I had a Canon Rebel that wasn't seeing a lot of day-to-day use. I had it modified for IR-only photography. The resulting tool was exactly what I needed to create some of my favorite and most compelling images.

On the technical side of things, I always shoot my IR images in the RAW file format. This gives me the greatest amount of headroom for recovering overexposed highlights in the initial file capture. As well, creating and using a custom white balance for your camera will help you to easily visualize and review your images during a photo session.

I find that one of the joys of photographing in infrared are the unexpected surprises you get after pressing the shutter-release button. While you generally need strong sunlight to produce optimal IR photos, feel free to break the rules now and then. Experiment with your camera settings and shooting conditions to find something special and unique.

Of course, photography is about so much more than technical details. It's also about emotions, situations and reactions. If you have a love for photography and an eye for the unusual, then you may well find yourself drawn toward an infrared romance.

*Ulysses Ashton • Photographer, Author, Lecturer • Ulysses Photography • www.ulyssesphotography.com*

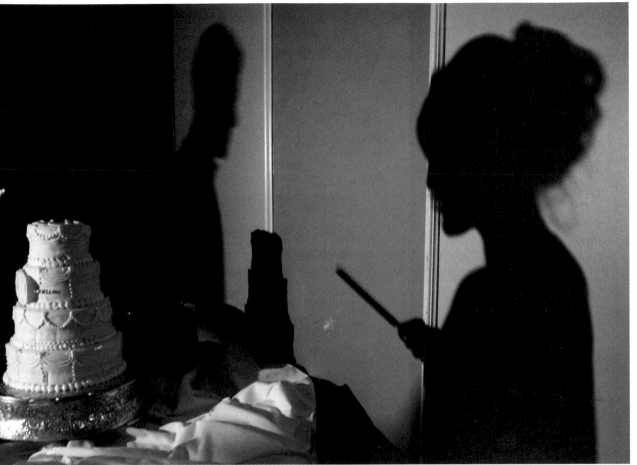

© Shane Snider

# Go Beyond the Clichés

We've all been in the position during a wedding shoot when things start winding down and it feels like we're just waiting for the next big setup event: the bouquet toss, the cake cutting, the dances. These things can feel less like rites of passage and more like hurdles you need to jump to get to the finish line of the night.

Vigilance, however, can pay off in even the most mundane of circumstances. Step back and take a look around you. Look for shapes to play with. Consider opportunities to expose for shadows, as opposed to always exposing for highlights. Be open to changing lighting situations.

You may think the safe shot is always the best option, but brides and situations will surprise you. Newlyweds are eager to have something creative in their albums. So do something interesting that will take your shots beyond the clichés.

*Shane Snider • Photographer • Shane Snider Photography • www.shanesnider.com*

# All Together Now

© Brian Ozegovich

A successful wedding photograph is the result of many elements coming together well. Those elements include composition, lighting, exposure and the pose.

For this image, I carefully positioned the bride so that the doors in the foreground would add a sense of dimension to the photograph and the tied drapes over the bed could frame her.

The even lighting throughout the photograph is a result of natural lighting with a flash positioned behind the subject.

Notice how both the bride's face and the scene outside the window are properly exposed. To learn that secret, check out Rick's tip on fill-in flash photography on page 68.

Before shooting I asked the bride to look down at her bouquet and to touch one of the flowers. The result is a timeless classic.

When you are making a picture, keep the "All Together Now" idea in mind.

*Brian Ozegovich*
*Park Ave Studio*
*www.parkavestudio.com*

© Gavin Seim

# Get Cinematic with HDR

This is a High Dynamic Range (HDR) image. To create an image with this effect, take three or more pictures at lighter and darker exposure settings, and then combine them using HDR software, such as Photomatix (www.hdrsoft.com). HDR offers a far greater dynamic range than a single exposure can provide.

When I plan an HDR image, I tell the subject to stand as still as possible, and then I quickly fire off three images using 2EV auto-bracketing. I always use a tripod and generally go with natural light. A cable release also helps because I don't have to touch the camera to fire the sequence. This keeps things stable.

Once I have the shots, I tweak them in post-production to get the final result. It takes time and it's not right for every image; but when it's done right, this technique will really set your photography apart.

For HDR wedding images, compose a broad, sweeping scene to achieve a wide cinematic look. Keep in mind that the closer you get to your subjects, the more exaggerated their movements will appear in the photograph.

To learn more about HDR, check out the HDR section of prophotoshow.net.

*Gavin Seim • Photographer • www.seimstudios.com*

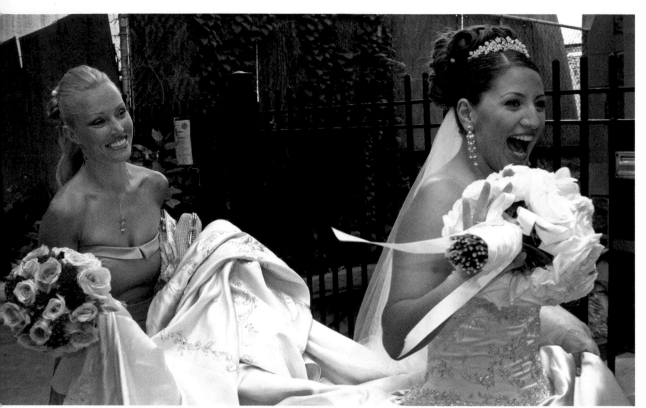

© Kerstin Hecker

# Follow Your Heart and Have Fun

Like many wedding photographers, my main goal is to make the client couple 100% happy. So when a bride and groom want specific photographs on their wedding day, I ask for a list so I'm sure to capture those special moments. I also ask for a schedule of events, so I'm on the spot and don't miss the shot.

Armed with this information, I know basically what to expect. I know I need to constantly be aware of everything going on around me and anticipate the reactions of people. I follow my heart and go for candid photographs that make me smile. This typically makes my clients happy and results in a sale. This fun-filled photograph is one such example.

Sure, from an aesthetic standpoint, the background in this image is not the greatest. But check out the expressions on the bride and one of her bridesmaids. It's a real fun shot—captured in the blink of an eye (and with the help of daylight fill-in flash) because I followed my heart.

Follow your heart—and don't miss a fun shot because it's technically not perfect.

*Kerstin Hecker Photography* • *www.kerstinhecker.com* • *kerstin@kerstinhecker.com*

© Steven Inglima

# Carve Out Time

When photographing weddings, insist that the couple makes time in their day to allow you to take some interesting and creative shots. No doubt, creative images are good for their album, but they are also good for your portfolio... and they help you hone your creative skills.

I always seek creative opportunities. I'm particularly attracted to reflective surfaces as a design component of creative portraits. The grille, mirrors, hubcaps... even the windows... of a limo are all highly reflective and can create interesting and captivating elements in a scene.

So remember, on the wedding day, get the standard shot of the bride and groom "carving" the cake, but also carve out time for creative photographs.

*Steven Inglima*
*Explorers of Light, Canon USA*
*www.usa.canon.com/dlc*

© Stephanie Smith

*Part 6*

# The Woman's Touch

You saw some of Stephanie Smith's wonderfully creative images in the previous chapter. Well, I was so impressed with her photographs and her willingness to share that it seemed right to give her a special section to provide you a woman's perspective of shooting wedding photography.

Check out more of her work on the following pages, and you'll see why I have the utmost respect for this dedicated and talented individual—whom I have never actually met, by the way. Thanks to the Internet for helping me find her!

Read more about Stephanie's photo philosophies, in her own words, on the next few pages. And if you still want more, check out her work at 831 Photography (www.831Photography.com).

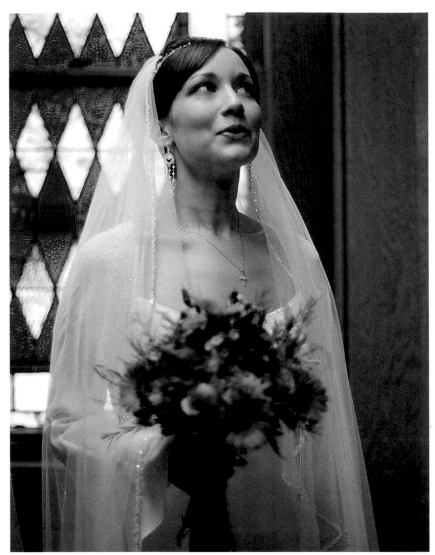
© Stephanie Smith

# Be Cool, Calm and Collected

My clients tell me all the time that I have a calming influence on them. When everything is crazy and everyone is stressed, I usually remain cool, calm and collected.

In the midst of commotion, a bride or her attendants will ask, "Is this normal?" I assure everyone that all weddings have chaotic moments and stressful times. Then I suggest that everyone take a deep breath, relax and just enjoy the moment— because it will be gone before they know it.

How can I remain so calm in the midst of the chaos? Well, I've been there before … hundreds of times as a wedding photographer. And more importantly, I have been a bride. I have been in those shoes, and I can relate to the butterflies that brides feel in their stomach. I know the anxiety, the excitement, the stress and the relief that they feel now that their wedding day has finally arrived. So when I tell them to relax and enjoy it, they know it is coming from someone who speaks from experience.

The bride in this image was very calm all morning while she was getting ready. However, when she arrived at the back of the church—waiting for her moment to go down the aisle—and heard the music playing, she showed her first signs of anxiety. She looked up to keep from tearing, took a deep breath and said a little prayer to herself. Then it was time to get the show on the road.

# Persuade

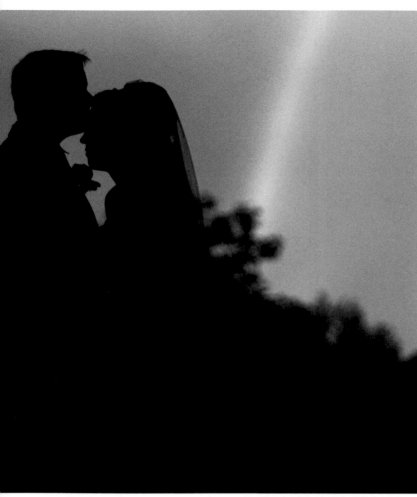
© Stephanie Smith

Sometimes, in order to get beautiful images, you have to ask your clients to do things they normally would not do. Groomsmen, in particular, can be challenging. Many times they don't want to do things that they think will make them look silly. However, because I am a woman, I often have an easier time than my male colleagues in convincing grooms to comply with photography requests.

One thing that rarely takes much convincing is when I suggest that the couple take five minutes and just enjoy a few moments alone together. I love getting them to just be together and soak in a few moments of each other on their wedding day.

It took just a bit more convincing than normal to get this couple positioned for this shot. A massive storm had rolled in just two minutes after their outdoor ceremony ended, which cut short our portrait time. So later, during the reception, when the rain had finally passed, I suggested that the couple join me outside for a few more pictures. They were very open to the idea of walking around the grounds of the wedding location, because the landscape was a main reason they had selected the site.

The sun was setting so we had very little time to shoot, but a beautiful rainbow developed and I knew that we had to capture it. I asked the bride and groom to walk into the grass on a small hill so I could line up everything the way I wanted. The grass was very wet which caused a moment of hesitation, but my clients trusted me and cooperated. They were rewarded with this memorable image.

© Stephanie Smith

# With a Little Help From Friends

Bridesmaids can be a tremendous help when shooting a wedding. They want the best for their friend on her wedding day, so they include me on inside jokes and things I should photograph. They provide insight that perhaps I would not get if I was male.

Maybe it's general female camaraderie. Women in general like to make others feel special, and so they go out of their way to make sure that the bride gets the very best of everything on her big day.

This image was created with the help of bridesmaids. I was in the back of the church, waiting for the bride to walk down the aisle, when one of the bridesmaids came out of the little room in which they were waiting to tell me that the bride was peeking through a crack on the hinge side of the door leading to the sanctuary. I went into the sanctuary and got the shot from the other side of the door.

Now the bride will always remember her smile as she saw her ceremony about to begin, and it is thanks to her bridesmaid…who let me know what was happening when I was elsewhere.

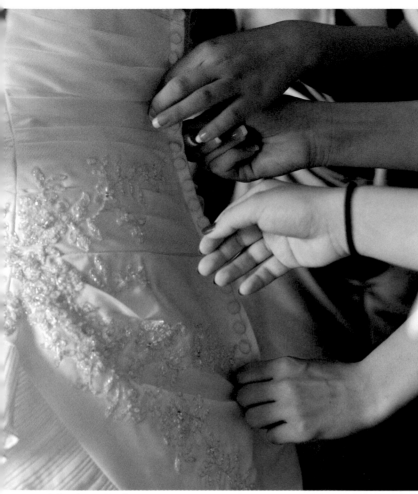

© Stephanie Smith

# Blend In

The brides I've worked with have been very comfortable with me photographing them getting ready. As a woman, I blend in with her mother and bridesmaids. This allows me to capture some of the most intimate moments that a bride has on her wedding day.

The time spent getting ready is when the bride transforms from her normal self into the stunning bride she has likely pictured herself to be since she was a little girl. It is amazing to see emotions change as the transformation progresses. Usually the veil is what sends the bride and the family over the top emotionally.

The bride has likely worn fancy dresses before, but only on her wedding day does she put on a veil. The bride tends to be less than fully dressed while getting ready and usually needs a handful of helpers to get into her gown. Getting into the wedding gown can be a fun and chaotic moment and one that definitely should be preserved.

I love this image because it shows how many people it takes to get a bride ready for her wedding.

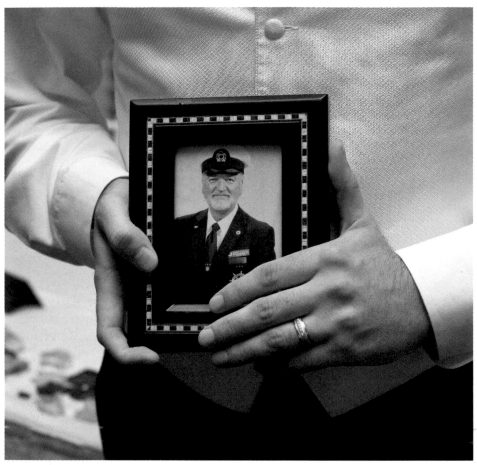

© Stephanie Smith

# Be a Friend

Often, my clients become my friends. It feels good to arrive at a wedding to photograph it and feel like I am spending the day with good friends. I appreciate that my clients feel comfortable with me and that they let me into their lives—allowing me to share this extraordinary time with them and their families. I often feel like a part of the family by the time I leave at the end of a wedding day.

Because I feel so close to my clients, I'm able to suggest and capture images that I would want if it were my own wedding. This photograph is one I created to bring my client's wedding day full circle.

The groom's father had passed away before the wedding. During the reception, they played a song dedicated to him. Afterward, those who were close to him drank a toast of his favorite drink. The best man was holding a picture of the groom's father while they toasted him, and I thought that it would be appropriate to capture an image of the groom with his father.

I asked the groom to hold the picture and I made sure I could see his wedding ring. I felt that this was a great way to show the groom starting his life as a husband—and maybe someday as a father—while including the memory of his own father.

© Stephanie Smith

# Think Creatively

I find myself trying to find new ways to look at things—all the time. I love to see things from angles that few others would think to consider.

For instance, I try to look for creative ways to show the wedding gown in photographs. Obviously, this is a very important part of a wedding day. And many brides spend hours trying on gowns before finding the one that's perfect for them. They examine all the aspects of the dress, and I love to take detailed images of it.

This detail of the dress is taken from a very unusual angle. I hung the dress from a light fixture in the room where the bride was getting ready. I used a wide-angle lens, got down low to the floor and took the picture only inches from the dress.

I loved the detail at the bottom of her dress, and that's what I wanted to highlight.

Keep in mind that beautiful images are even more beautiful when they are captured in creative and different ways.

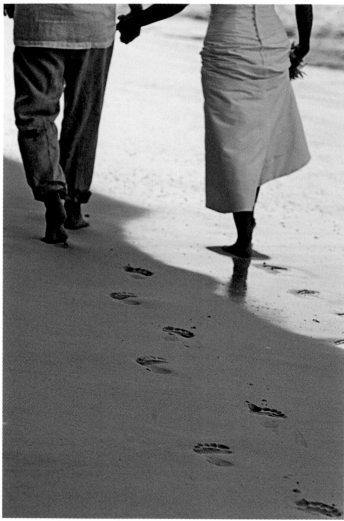

© Stephanie Smith

# Follow Your Instincts

When I started my wedding photography journey, I didn't know of any female wedding photographers. Instead of limiting my growth and development, this was a bit liberating; it pushed me to cut my own trail.

That is to say, the lack of female mentors freed me to create my own vision and develop a style that came from my own instincts and vision. In doing so, I eventually found that I was breaking a lot of the traditional photography rules.

Part of my photography style is capturing bodies—hands, in particular. I'm not as concerned with getting a face in every image. I believe that you can tell a lot about a couple and their relationship through their body language. Hands are especially telling.

In this image, I wanted to catch the couple in an environment in which they are comfortable. Walking on the beach hand-in-hand is a natural activity for this couple.

By watching them walk, I was able to build an image that told a much larger story than a basic portrait. I focused on the footsteps they left in the sand to show that where they have been is just as important as where they are going. I was able to show the beginning of their new journey as a couple.

Follow your instincts and create interesting stories.

*Part 7*

# The Creative Touch

Stephanie Smith contributed the insightful material for the previous chapter. In this chapter, her husband, Shannon Smith, offers additional advice and creative ideas on how to turn what could be standard wedding snapshots into memorable photographs.

Like Stephanie's chapter, this is written in Shannon's own words and is accompanied by his creative, personal and fun images—such as the McDonald's window shot, which you'll see in a few pages.

You can check out more of his work at 831 Photography (www.831Photography.com).

# Anticipate the Moment

Receptions are full of unscripted, fleeting moments. In this image, the bride had pulled out her husband's wallet, joking around. After capturing the laughs and smiles, I circled the dance floor hoping she would put it back in for him—and it paid off.

The tight crop, playful angle and hints of people in the background all add to the fun feel of this image.

Even though I missed her pulling the wallet out of his pocket, I anticipated what might come next and was able to capture the image I wanted.

Another way to give this advice is to say, "Think ahead." It's something all good wedding photographers do.

# Focus on the Attendants, Too

One of my favorite subjects at a wedding, aside from the bride and groom themselves, are their attendants. Obviously important enough to be a special part of this big day, attendants are always great subjects. Photographs of them are guaranteed to have a special meaning for the newlyweds.

In this image, the flower girl quietly went out to the hallway during the reception to sign the guestbook. The setting was perfect—candles, white tablecloth, good background—but there wasn't enough natural light to freeze the action.

At the time, my assistant had a flash on a monopod that was controlled by a radio trigger, so I simply had them bounce the flash off the ceiling. Our beautiful flower girl was close enough to the table that we could use it as a natural reflector. Therefore, her face didn't fall deep into shadow, and the lighting wasn't overpowering to the natural light coming from the candle.

Color balance was an issue though, as there were three distinct sources of light: overhead fluorescent bulbs, the warm candlelight and our flash. I wanted to keep the warm feel but needed to lose the clash of colors. A simple sepia toning did the trick.

By keeping my eye on the bridal party and being able to predict how light would be reflected—and then making some simple adjustments in Photoshop—I was able to capture this delicate moment without interaction. It turned out to be one of the bride's favorites!

So the tip here is to include the wedding attendants and not focus exclusively on the bride and groom.

# Set Yourself Free

I almost always work with a second photographer, because this frees me to get creative with my photography without worrying about missing the traditional shots. This image is a perfect example of the rewards of being free to experiment with creative angles and techniques.

In this image, I knew the cake was very important to the bride. Rather than using the traditional wide-angle lens, I used my 70-200mm lens and focused on the slice they were about to share. The bride, completely out of focus in the background, shows her complete joy while I captured a great shot for their album.

When you set yourself free, you'll come up with more creative images.

## Keep It Fresh

I always try to keep my eyes open for fresh, new locations and scenes. In this case, we were approaching the church, and I saw the sign as we pulled in. I knew we had to take the groom out there immediately. It totally fit his personality.

Always observe your surroundings, and you'll find that opportunities for unique images present themselves to you.

As long as I am talking about keeping you eyes open, it's a good idea to learn how to shoot with both eyes open—like a sports photographer. When you do this, you can, among other things, see if another person is about to walk into the scene, which can either add to or take away from the image you capture.

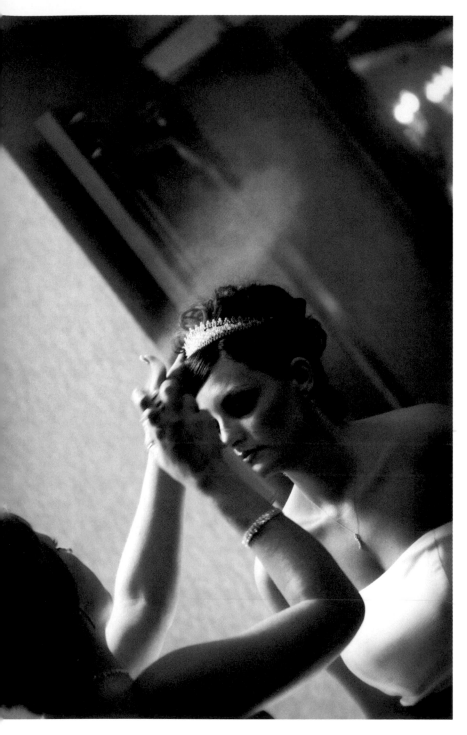

# Use Natural Light When it Feels Right

When possible, use natural light. In this case, there was a skylight off to my left, and I saw the bride getting her hair touched up before walking down the aisle. If I had used a flash, the mist of the hairspray would never have shown up with such depth. By waiting for the right moment and not overpowering the scene with light, I was able to capture this striking image.

As with all your photographs, it's important to see the light and know how to control it on site—with a flash, reflector or diffuser ... or by repositioning the subject. Afterward, know how to manipulate the effects of light in Photoshop.

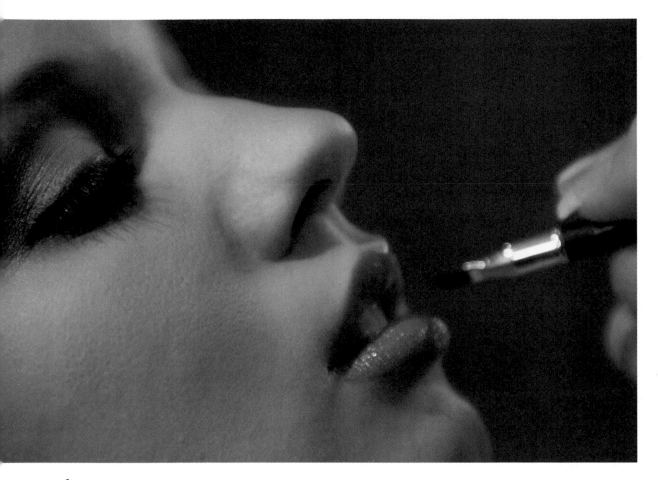

# Eliminate Distractions

During the makeup session, try to get in close to your subject(s) in order to eliminate the many distractions found in salons.

Wait until the lipstick brush is just off the bride's lips to shoot. This creates a feeling of anticipation and avoids the strange open-mouth face that usually accompanies lipstick application. Also, since lipstick is typically the last touch of a makeup session, the bride's skin appears much smoother—and the eyes are much more dramatic—at this point in the day.

Being close to the subject also creates sharpness in the image, because the frame is filled with only the important details.

A little Photoshop work sometimes is necessary here, because being this close can be unforgiving. The results are dramatic though. Even the bride's brother was in shock. He didn't recognize her at first and commented on how hot this woman looked! A good lens for these situations is a 17-400mm zoom lens.

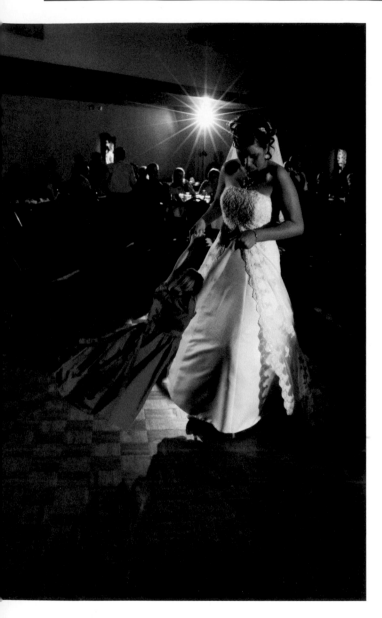

# Bring Your Own Lights

Reception halls usually have some of the toughest lighting a photographer will ever face. They are typically low, extremely warm (tungsten lights get warmer as they are dimmed), and positioned directly overhead— casting eyes into shadow to create "raccoon eyes."

Of course, using the flash on your camera helps but, even then, you're left with dark backgrounds and possible red-eye. Some photographers use high ISO settings and drag the shutter, allowing more ambient light in to lighten the backgrounds, but this can cause extremely warm backgrounds and shadows along with motion blur and noise.

A great solution to this problem is to just bring your own lights. Set up four manual flashes on light stands and position them around the room. Trigger them with radio triggers.

Use manual mode to get consistent power and light up the entire dance floor. Since you're not using the ambient light in this scenario, color balance won't be an issue. Get great starbursts in your pictures by including the overhead lights in your shot.

Diffusers are generally unnecessary if you place your light stands in corners, because no matter the angle, you will always have a main light, a fill light and two rim lights.

That's it. Studio quality lighting at the reception is easier than you thought, eh?

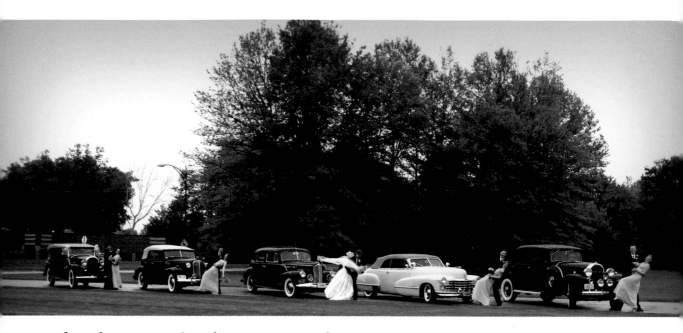

# Think Outside the Rectangle

Sometimes, cropping makes all the difference between good and great. In this case, the bride and groom used antique cars to transport their bridal party from the ceremony to the reception, and they wanted an image that captured these stunning automobiles.

The weather was dreary, so we had a very short window of time to get photographs without everyone ending up soaked. We had to work quickly.

On the way to the reception, we found a circular driveway, so we had the cars pull up to the edge, and I went across the little strip of grass. The bridal party was positioned in front of their vehicles, and I snapped three shots.

Unfortunately, to get the wide angle to capture all the cars, I ended up with a foreground featuring an unflattering parking lot. A simple crop transformed this image from average to great. Eliminating the foreground distraction resulted a nice panoramic image for the bride and groom to cherish forever.

Remember, just because your camera captures in a 2:3 format doesn't mean you are limited to that size for your finished image.

## Make Suggestions

One thing I like to do is suggest situations, rather than poses. In this case, I suggested that we stop at a McDonalds near the church. What a fun shot!

Don't be shy; make suggestions.

# Scan the Crowd

During the ceremony, there are periods of time when a photographer will wait for the next reader, the exchange of vows or some new scene to present itself. We are often restricted with our movement options and want to keep a low profile.

At these times, I often scan the pews for less-traditional images. Many times, children are excellent subjects, as they rarely are as interested in the ceremony as the adults, and they find amusing ways to distract themselves.

This image is a classic example. The bride and groom are holding hands, ready to exchange vows, and this young boy is clearly bored with the whole situation. As he looks around, I focus on him, ready for the eye contact I know is coming.

By observing the entire wedding, rather than focusing only on the main group, you will be able to capture many images that are easily overlooked. You also end up with photographs that tell a more complete story of the wedding day. Since these small moments and situations are rarely noticed by the bride, groom … or even the child's parents…presenting beautiful photographs of them will likely make the newlyweds very happy.

# Work with Reflections

Reflections are almost always a sure-fire way to capture unique images, especially when you give the viewer two separate subjects to see. Sunglasses are perfect for reflections. They allow you to capture in your photograph what the primary (or secondary) subject is seeing.

A great technique is to turn your flash toward the reflected subject. Because your point of view will be different from the angle of your light source, you immediately get off-camera lighting and shading—without any extra equipment.

The added bonus of being able to see both facial expressions practically guarantees this will be a favorite image for both the bride and groom.

As I mentioned earlier in this chapter, seeing the light in a scene and knowing how to control its effect is critical, especially when working on an image such as this.

# Do a Double Check

When capturing the exit, I always check two things on my camera. I make sure the high-speed drive mode is enabled and that my flash is on.

The exit is usually shot outdoors, and the bright sunlight can create harsh shadows under the eyes, ruining an important image. By using my flash to fill in these shadows, the newlywed's expressions are easily seen and their eyes have a nice catch light, which gives them some sparkle.

The drive mode allows me to capture multiple images, as it is very unpredictable where things like petals, rice or, in this case, streamers will fall. Having multiple images allows me to choose the absolute best smile, position and lighting.

Remember, it's easier to throw away bad images than to wish you had captured a better one!

## Observe Body Language

Many times, I like to give my clients some alone time, especially when they have been running around all day. This is usually a rare treat for them, since they are pushed along by their timeline all day long. This alone time usually results in some of the most memorable moments of their big day.

Yet I never keep my eyes off of them during this time, because their emotions are easily seen through their body language. I like to use a longer lens for these shots to stay out of view, so the couple can interact naturally.

In this case, I was inside the reception hall, shooting through the window. I was watching the groom look at all the beautiful details of the wedding bouquet that the bride had so carefully chosen. It was obvious he wanted to make sure he noticed the details.

The panes of glass added interest to the image, and helped frame them in an otherwise plain pre-winter background.

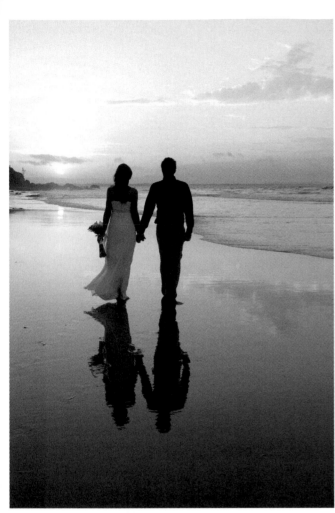
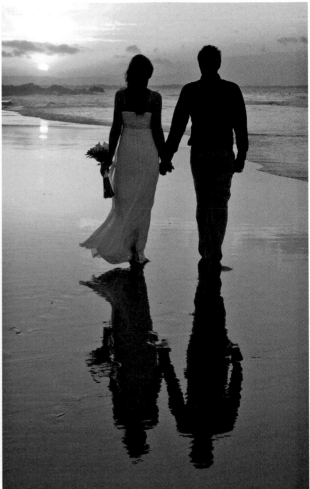

*Part 8*

# Photoshop Must-Know Info

If you are new to the wonderful world of Photoshop, this chapter is just what the doctor ordered. It offers all the basic stuff you need to know about Photoshop.

Sure, Photoshop can be intimidating. That's why this chapter is included in this book. It gives you a strong foundation for working on your images, which is covered in the next chapter.

# Never Work on the Original Image

This is the mother of photography basics: Never work on your original image files. It's just too risky.

Not convinced? Consider a scenario in which you finish making all of your adjustments and enhancements and then you accidentally press Save rather than Save As. Uh oh! Your original may be lost forever—unless you shoot RAW files, which always remain as RAW files.

Lose that magical "first kiss" or a "secret kiss" photo, and the bride and groom will be more than a bit upset with you!

So it's absolutely critical to always—always—back up your image files. Save them in at least two places, because chances are … your hard drive will eventually crash, sending your one-of-a-kind pictures into "never never land" forever.

My advice is to back up these precious files using an accessory hard drive, which can accommodate more files than a DVD. Also, the write speed to a hard drive is much quicker than it is to a DVD.

Of course, the bride and groom may want a DVD of their wedding pictures. That's great; make it. And when you burn their DVD, make an extra copy for yourself … in case their DVD gets scratched and becomes unreadable. Or, if you're feeling generous, offer the newlyweds a special deal on two DVDs!

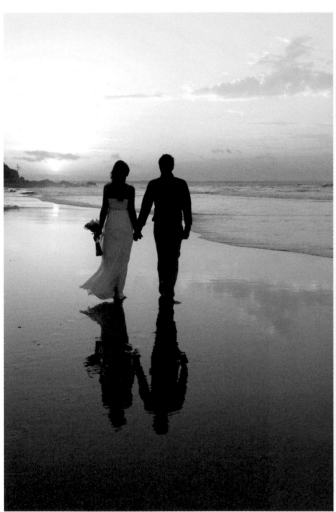 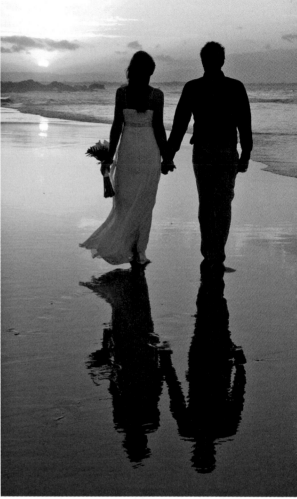

# Stop!

Okay, I know the title of this tip is a bit dramatic, but I want to make an important point. When you open an image in Photoshop, the first thing I suggest you do is stop. Take your hand off your mouse (or set down your stylus) and look at the image. Look carefully. Pay attention to what you like about the image and what you dislike.

After doing this, you can think more productively about what tools and adjustments and techniques the photograph requires.

Jumping into edit mode too quickly will ultimately slow you down in most cases. Not thinking things through often results in a need to either start over or go back several steps to get it right.

Here is one before-and-after example. Thinking about cropping, boosting saturation and using Levels before getting to work helped me visualize the end result ... and get to it (somewhat) efficiently.

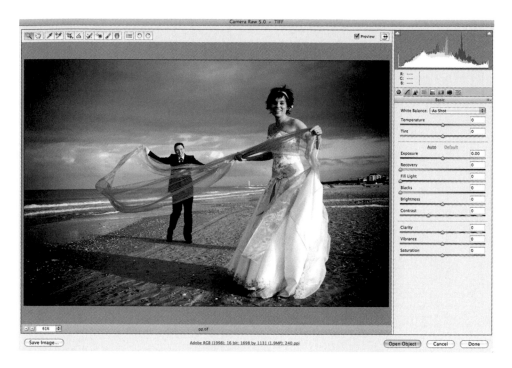

# Learn Camera RAW

Some wedding photographers shoot only JPEGs—mostly for speed, because writing RAW files to a card takes longer than JPEGs. Working on RAW files is also more time consuming.

So JPEG photographers are pleased with their results, as are their clients … if the exposures are right on! If JPEG images are over- or underexposed, detail can be lost forever in the highlight and shadow areas, respectively.

RAW files are more forgiving than JPEGs when it comes to exposure. That is, details in highlight and shadow areas of RAW files can usually be rescued with Adobe Camera RAW (ACR) or Adobe Lightroom or Apple Aperture. All of these products offer tools to expertly fine tune RAW files.

The ACR window, which changes to reveal even more options as you click through the adjustment tabs, offers all the basic adjustments a wedding photographer (and any photographer, for that matter) could hope for. With it, you end up with images that not only have better exposure, but also are more creative, more dramatic and unique than without it.

Simply put, RAW processing is a very powerful image-editing tool. As you'll see in the following section, it can even enable you to do things in Photoshop like change the direction of light in a scene. How cool is that?!

Attention JPEG shooters. Good news! You can process your photographs in ACR, too; although you'll still be working with a file that has less information than a RAW file. In Photoshop, go to File > Open and choose Camera RAW as the Format. Your image will open in ACR and you'll be able to begin adjusting your image with this program.

# Understand Image Resolution

Understanding image resolution is an essential part of being a photographer. The bride and groom will likely have no clue about file size and resolution issues. Why would they? It's up to you to determine the correct image resolution, so your clients get the photographs they're hoping for.

My advice is to save a copy of each file at its highest resolution. That way, the couple can choose to have a BIG print made without a loss in detail. What's more, if they want to print only part of an image, you'll have more pixels available to create that print.

For an 8x10-inch print and other standard album sizes, an image resolution of 360 PPI at the print size is sufficient.

If you make a print at too low of a resolution, your image will look pixilated, as shown in the image on the right.

For web sites, which typically accommodate images around 4x5 inches, a resolution of 100 PPI at the image size is fine.

To change the size of an image, go to the Image Size window. When upsizing, choose Bicubic Smoother; choose Bicubic Sharper when downsizing. These settings will give you the best results.

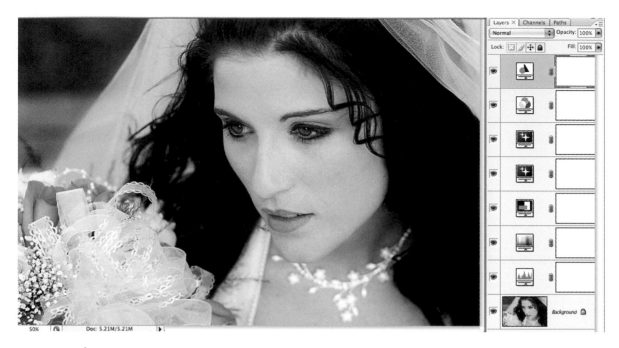

# Love those Layers

The layers function is perhaps the most important aspect of Photoshop for the creative photographer. What is a layer? Well, think of a layer cake … In Photoshop, each layer is a different version of your original image.

For example, you may have a Hue/ Saturation layer, where you boost the saturation of an image. The Levels layer may show adjustments to the brightness, contrast and tones. Other layers will handle other functions of image adjustment.

One of the main advantages of working with Adjustment Layers is that you can use layer masks to paint in-and-out effects for selective enhancements. Another benefit is that you can delete a layer if you don't like your adjustment, or you can go back and change it tomorrow … or years from now.

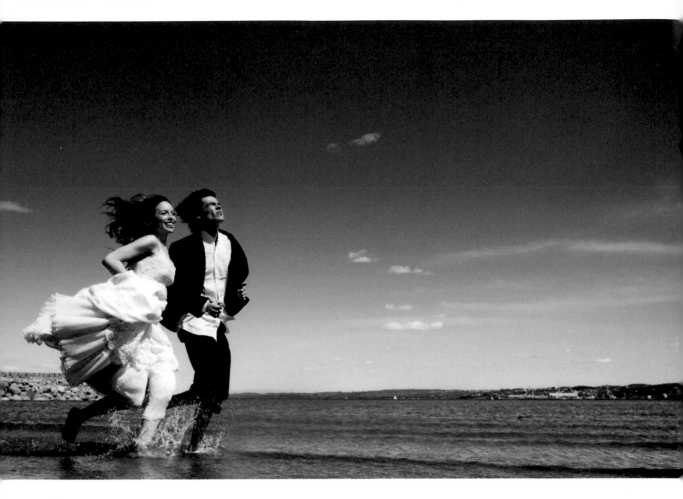

# Save It

After creating a file that contains several layers, you'll want to save it either as a TIFF file, a PSD or a JPEG.

When you save a file as a TIFF, all those adjustment layers are saved individually, so you can go back and change or delete your adjustments at a later date. Just keep in mind that TIFF files and PSD files take up more space on your hard drive than JPEGs.

When you save a file as a JPEG, you flatten the image and consolidate the file. Your layers are lost forever when the file becomes a JPEG, but this is an ideal format for images you deliver to clients who want to post their wedding pictures online, e-mail them and/ or create a digital slideshow on DVD. Given their smaller file size, JPEGs are best for these electronic applications.

Before printing, you'll also want to flatten your images by saving them as JPEGs to minimize file size and decrease printing time.

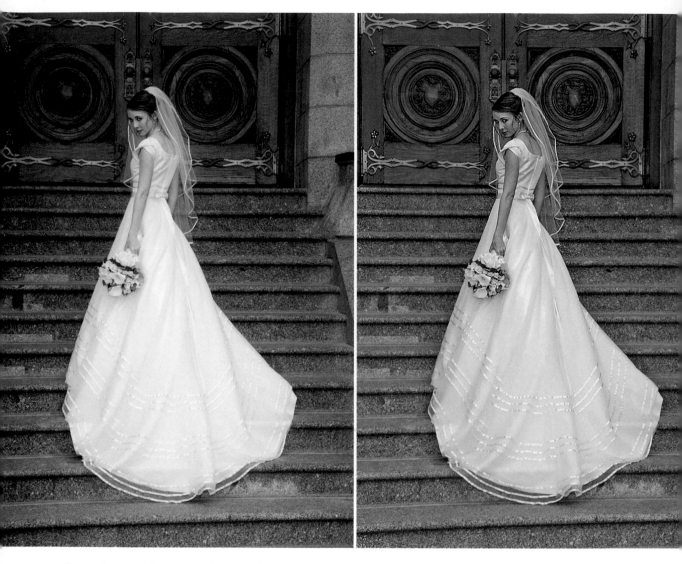

# Think and Work Selectively

Thinking and working selectively on an image is an important part of the creative Photoshop process. Many times you want to sharpen, lighten or darken only part of an image. That is thinking selectively.

*Working* selectively involves working on only those areas. You can do that easily when you create an adjustment layer and use a layer mask. Some examples of adjustment layers and layer masks are only a few pages away.

In this example, I selectively darkened the bride's overexposed gown and then I sharpened it (and her). As far as the background is concerned, you can see that I selectively lightened it.

# Get to Know Options

The Tool bar on the left side of the Photoshop window provides you options for adjusting your image in various ways. Yet it's the controls on the Options bar, located at the top of the Photoshop window that helps you fine-tune your tools.

Play around with the Options bar, and you'll see that your capacity for creatively using your Photoshop tools is greatly increased.

One idea for learning about Tools and Options is to try learning a new one each day ... or maybe one each week. Give yourself time to absorb each new technique. In less than a year, you'll know as much as most pros.

# Master All the Adjustments

Photoshop adjustments can help you make virtually any change to a photograph that your heart desires. But the sheer number of options can be a bit overwhelming at first. What's more, some of them, like Levels and Curves, can get you to basically the same place but with subtle differences.

My advice is to experiment with all the adjustments on just a few images so that you can learn how the adjustment works. Click on all those little fly-out arrows to see even more options.

As with Photoshop's Tools and Options, try to master one at a time ... even though you will be tempted to try to learn them all overnight.

# Sharpen Last

All RAW files need sharpening, as do some JPEGs. However, it's important to know that JPEG files are already sharpened when they come out of your camera. The saturation and contrast have also been increased, which I personally don't prefer.

When you think about sharpening an image, plan to make this your final step in the image-editing process. You want to sharpen last because other adjustments, such as Levels and Curves, which need to be made early on, affect image sharpness.

I like to use Smart Sharpen (Filter > Sharpen > Smart Sharpen). It offers more control than Unsharp Mask (Filter > Sharpen > Unsharp Mask), which was the tried-and-proven sharpening method before Smart Sharpen was introduced.

# Don't Over Do It

It's natural to want to sharpen an image to make it pop with detail. It's also tempting to boost saturation for a vivid image. However, if you sharpen an image too much, it will look pixilated.

My advice when sharpening is to view the image at 100% on your monitor and gradually sharpen it to your liking. Just don't overdo it.

Another idea is to crop your image to show only the most important part of the scene. Sharpen that part of the file and make a print. Check it out. If it looks good, it's probably okay to apply that level of sharpening to the entire image. Understand, however, that sharpening an image increases noise in shadow areas more than it does in highlights.

As far as saturation goes, if you overdo it, you can lose detail in very saturated areas—such as bouquet photos that include very deep red, yellow or orange areas. Here, less is often better.

Hey! Remember I mentioned thinking selectively a few pages back? Well, that goes for sharpening and increasing saturation, too.

# Expand Your Horizons with Plug-ins

Want to have even more creative control in Photoshop? I'm thinking you do, because it can give you an edge over your competition and show your clients you are indeed an artist. Using plug-ins is an easy way to achieve this.

Plug-ins offer artistic effects at the click of a mouse or tap of a stylus. They help you add effects—such as changing the lighting, color, grain, tone and other aspects of your image— that would otherwise take you hours to create. They can be downloaded from the Internet or loaded to your computer via CD.

OnOne software (www. ononesoftware.com) offers two of my favorite plug-ins: PhotoTools and PhotoFrame. Within these two plug-ins, you'll find hundreds of effects. Here I used the Davis Wow Muted Colors in PhotoTools and then applied one of the camera frames on PhotoFrame Professional.

Play with plug-ins. They range in price—from under $100 to a few hundred dollars—but the time they'll save you in digital editing ... combined with the quality of your results ... guarantees the investment will pay off.

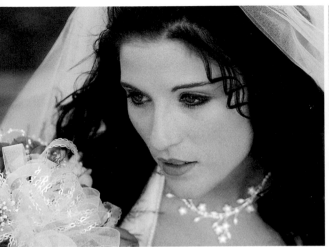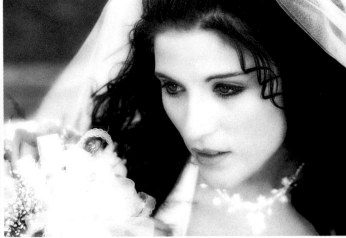

*Part 9*

# Photoshop Adjustments and Enhancements

Known as a Photoshop expert, I help other photographers understand how to use this tool by providing seminars and by teaching at Photoshop World and through online Photoshop classes at kelbytraining.com.

I truly enjoy teaching Photoshop for three main reasons. One, it gives me opportunities to help photographers enhance the quality of their photographs by showing them how to correct (some) technical mistakes. Two, I can help photographers motivate and encourage the artist that lies within them. Three, it's fun to play with Photoshop!

In this chapter, I'll show you a little of each: fixing, awaking and having fun. And from a business standpoint, if you master a few of these techniques, you'll have more to offer your clients.

# RAW Rules

Simply put: RAW *rules.*

A RAW file has a wider exposure latitude (exposure-recording and correcting range) than a JPEG file. This means, when working with a RAW file in Photoshop (or Lightroom, Aperture or your camera's software program) you can rescue overexposed areas of an image (up to one f-stop). Many photographers (including me) shoot only RAW files and process their images in Adobe Camera RAW (ACR), which has many image-processing options.

But wait! Even if you shoot JPEGs, you can take advantage of ACR by going to File > Open and then choosing Camera RAW as the format. You won't be able to rescue highlights as well on JPEGS as you can on RAW files, but you will find many creative and correction options at your fingertips in ACR for JPEGs.

So while this section is focused on Photoshop adjustments and enhancements, ACR is a good place to start for standard image adjustments.

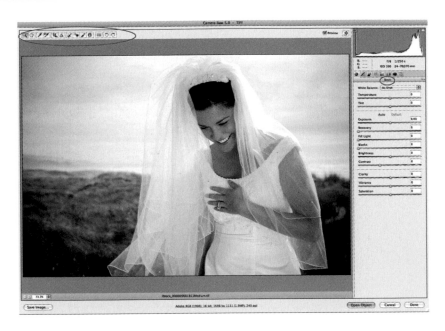

The Camera RAW dialog is where the magic of image adjustment takes place. Experiment with the Tool bar at the top of the window. As in Photoshop, ACR provides many tools for enhancing and correcting your images. On the right side of the window are the Adjustment panels. Basic is shown here, and it's sufficient for making most of your adjustments.

After you play around with Basic adjustments, click the tabs for Tone Curve, Detail, Lens Correction and HSL/ Grayscale for even more fine-tuning capabilities.

Sure, all this takes time, but when you really need to fix an image, RAW rules.

# Save the Bridal Gown

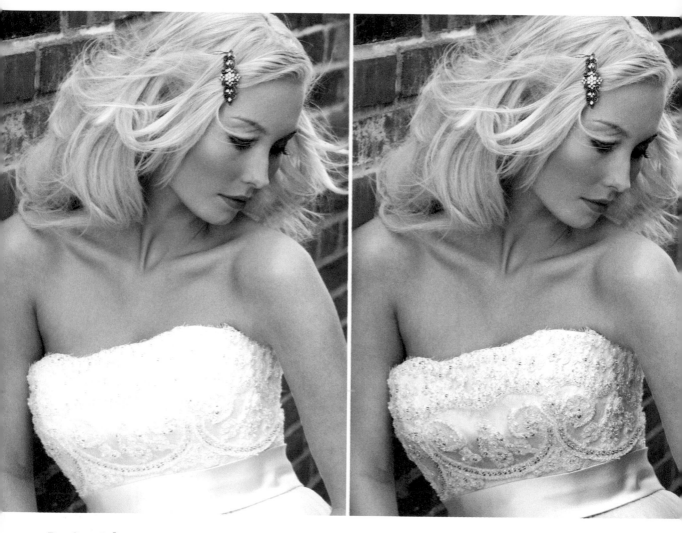

Don't get down over seemingly lost detail in a bride's gown. Use Photoshop's Shadows/ Highlights to easily rescue those beautiful details.

One of the last things you want to do as a wedding photographer is disappoint the bride with a photograph that does not show all the gorgeous detail in her gown. That can easily happen when you are shooting fast and/ or don't set your exposure properly. The fix is to use Shadows/ Highlights.

**Step 1:** Open your document and reveal the Layers panel. Click (and don't release) on the background layer and then hold down the Control key. That brings up the Layers Properties dialog.

Select Convert to Smart Object. You do this for two reasons. One, you don't want to use the Shadows/ Highlights adjustment directly on your original file. Two, this process lets you use Shadows/ Highlights as you would use a layer mask—on which you can mask in and out an adjustment or effect. How cool!

**Step 2:** Next, go to Image > Adjustment > Shadows/ Highlights.

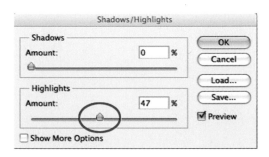

**Step 3:** Tone down the highlights by moving the Highlight slider to the right. Move it just far enough so that the details in the bride's gown are revealed. Don't worry about how the bride looks! At this point, she may look a bit off color and incorrectly exposed. That will be corrected later.

**Step 4:** In your Layers panel, you'll see that a layer mask has been applied to your image (because you converted the image to a Smart Object). Here is how to mask that effect.

First, set black as your foreground color in the Color Picker, located at the bottom of the Tool bar. Select a soft-edge brush. Click on the Smart Filter mask in the Layer's panel and mask out (paint over) the areas of the image, including the bride and other areas that you don't want affected by your adjustment.

If you mask out part of the bride's gown accidentally, press the X key on your keyboard. This will change the foreground color from black to white and vice versa. Then paint back in the effect.

Voilá! No more disappointed brides, thanks to this easy-to-use adjustment.

# Draw More Attention to the Subject

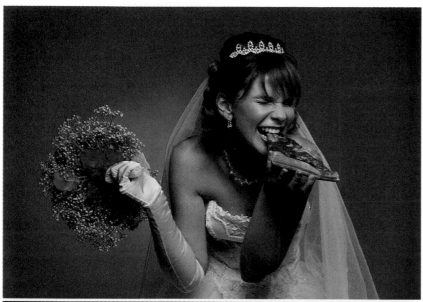

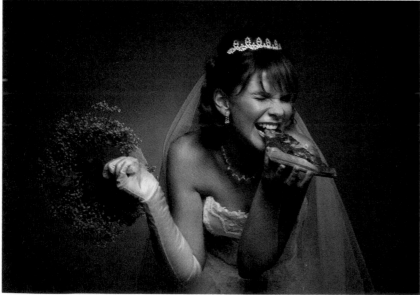

The headliner of a wedding is the bride. At least that's the case for most weddings!

You can quickly and easily draw more attention to the bride in a photograph by darkening the edges of the image. Hey, it's what the Renaissance painters did when they wanted the viewer's attention to be focused on a specific subject.

The technique is to create a quick vignette.

**Step 1:** Open your file and go to Filter > Distort > Lens Correction.

**Step 2:** Uncheck the Show Grid box at the bottom of the dialog, so you can see what the heck you're doing!

**Step 3:** Move the vignette sliders to the left until you are pleased with the effect.

Optional Step: If the bride looks too dark after you apply the vignette, use the History Brush (on the Tool bar). Paint back the original exposure by brushing over her.

# Change the Direction of the Light

Often, when we look at an image, we wish we had used a different lighting technique. Perhaps we wish we could change the direction of the main light. Or, maybe the shot was taken outdoors when lighting conditions were not ideal. These issues are easy to fix in Photoshop.

The technique is to use the Lighting Effects filter.

**Step 1:** Open your image and go to Filter > Render > Lighting Effects. Don't panic when that window opens. There's a lot going on there, but you only need to know a few basic controls.

**Step 2:** Select Spotlight as the Light Type. Other options are available, but start with this one. Grab one of the handles in the Preview window to create the direction and angle of the light. Next, adjust the Intensity and Exposure until you are pleased with the lighting on your subject(s).

It's that easy …
and that much fun!

# Don't Overlook Basic Enhancements

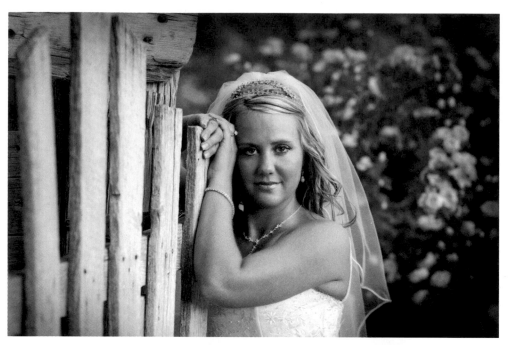

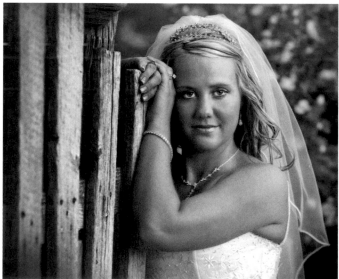

Sure, there are hundreds of creative and corrective adjustments and effects available in Photoshop that can help you make a client happy with the photographs you deliver. But in your quest for client bliss, don't overlook the basic enhancements.

Dodging, burning, cropping, sharpening and saturation are covered here.

The photographer had a good idea here, which is to pose the subject in a nice setting—one with a fence foreground and flower background. However … because the fence is bright in the scene, it's distracting.

Use the Burn tool, located on the Tool bar, for a quick fix in this situation.

Also, look closely and you'll see that the bride's eyes in the lower image are brighter than they are in the top image. To create this effect, use the Dodge tool, set at a low opacity (5%), to whiten just the whites of her eyes.

Eliminate unnecessary elements from your image using the Crop tool, located on the Tool bar. Although, when you crop, be mindful of the image size. If it's not a standard format—8x10 inches for example—you'll need to make a custom matte if the photograph is going to be framed.

Sharpen your image to give it more "pop."

To boost the saturation of an image to give it more life, use a Hue/ Saturation Adjustment Layer.

# Blur Reality for An Artistic Image

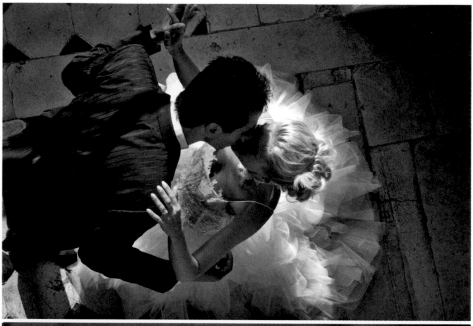

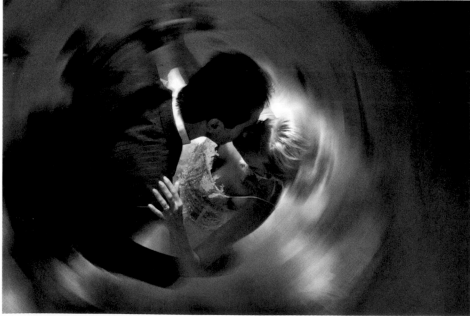

When you remove some sharpness from a scene, you also remove some reality. When some reality is removed, an image becomes more artistic.

Use the Radial Blur filter to add a sense of motion—and an artistic touch—to an image.

**Step 1:** Open the image file and go to Filter > Convert to Smart Filter.

**Step 2:** Go to Filter > Blur > Radial Blur.

**Step 3:** Select Spin, and play around with the Amount slider. Don't overdo it though.

You can place the center of the blur effect anywhere in the image by clicking the center of the window and moving it.

**Step 4:** Go to the Levels panel.

When you converted the filter to a Smart Filter, you added a layer mask to the file. Now, with black selected as the foreground color and with a soft-edge brush selected, use a circular motion to mask out (some call it *paint out*) the blur over your subjects.

Here is an important tip: As you move out from the center of the image (the main subjects), go to the Options bar at the top of your monitor and reduce the Opacity of the brush. The idea is to have a smooth transition between the sharp and blurred areas of your image.

# Easy Selective Color Adjustments

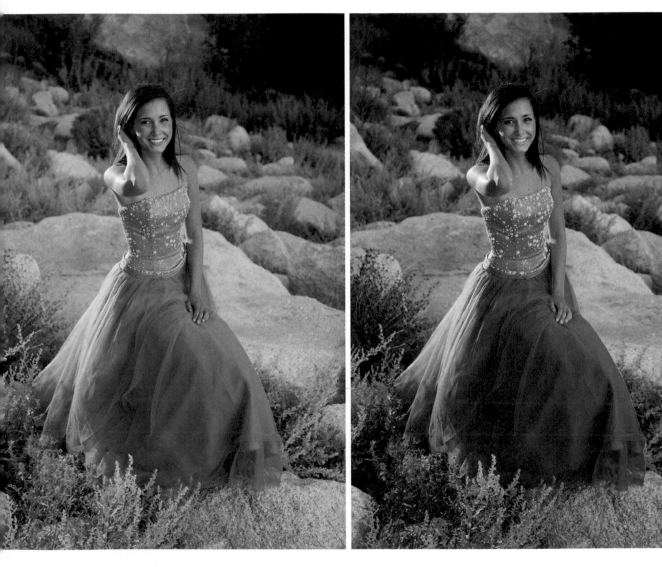

How often have you wanted to selectively adjust the colors in an image?
Well, if you are like me, the answer is quite often!

The solution starts with a black-and-white adjustment layer, believe it or not.

**Step 1:** Open an image and create a Black-and-White adjustment layer by clicking on the New Adjustment Layer icon in the Layers panel.

**Step 2:** In the Layers panel, change the Blending mode from Normal to Luminosity.

**Step 3:** In the Adjustments dialog, click on the hand/double-arrow icon.

**Step 4:** Move your cursor onto the image. (It appears as a hand/ double-arrow icon.) Now, simply move the cursor left or right to adjust the tones found in the area on which you are clicking. Cool, eh?

# Save Time! Use the Image Processor

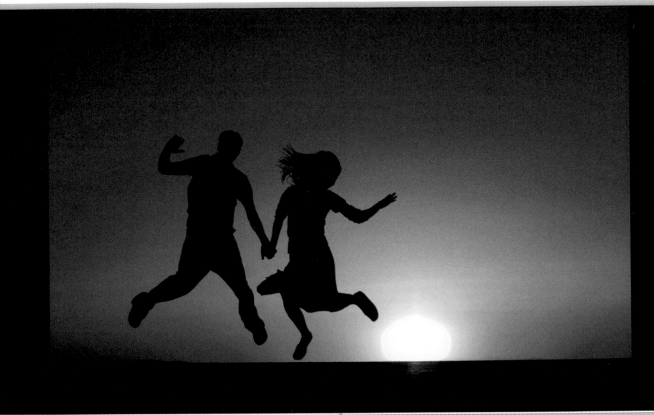

Okay, so you come back from shooting a wedding with hundreds of RAW files. You need to post several files quickly on your web site. Here is a fast and easy way to convert all those super-large RAW files to much smaller JPEGs quickly and easily—maybe even while you take a nap.

The Image Processor is your key.

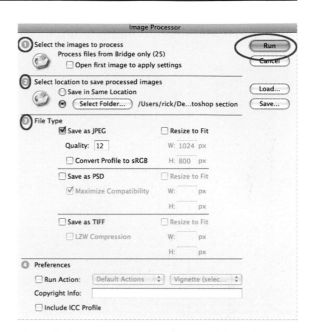

**Step 1:** Open Bridge and go to Tools > Photoshop > Image Processor.

**Step 2:** In the Image Processor dialog, follow these steps:

1) Process the selected files from Bridge.

2) Choose a location for the folder with the processed images (which should probably be different from the folder that holds the RAW files).

3) Select JPEG (or TIFF or PSD… or all three). If you choose JPEG, choose your quality setting and size setting. You can leave the images at the same size or resize them.

4) Click Run… as long as you don't want to apply any Preferences.

If you use Photoshop, you can process files of folders without having to access them through Bridge. In Photoshop, go to File > Automate > Scripts > Image Processor and then follow steps two through four as described above.

# Mix It Up

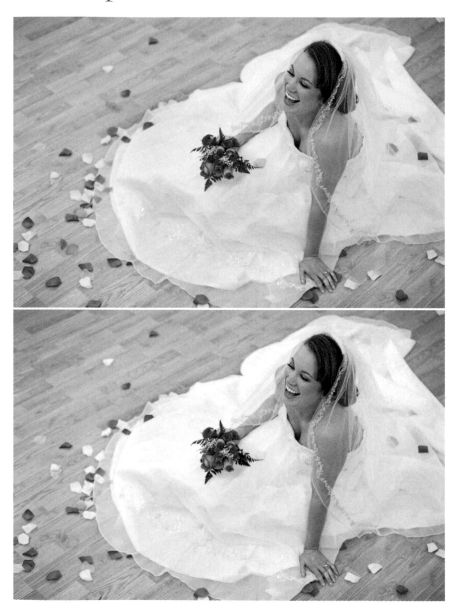

I am sure you've seen this cool effect in fashion, beauty and bridal magazines. It shows the subject in color and the background in black-and-white. Easy as pie!

The trick is to selectively choose which areas you want in color ... and which areas you want in black and white.

**Step 1:** In the Layers panel, choose a Black & White adjustment layer. You can also go to Layer > New Adjustment Layer > Black & White.

**Step 2:** When you create an adjustment layer in the Layers panel, a layer mask is automatically added. Now, with black selected as your foreground color, choose a soft-edge brush and paint over the areas of the image you want in color.

**Step 3:** Check the Layers panel and look for areas you may have missed.

**Step 4:** Don't tell your clients how easy it was to create this effect ... wink.

# Make the Bride Glow... More

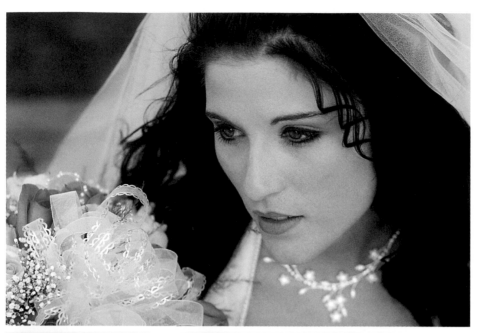

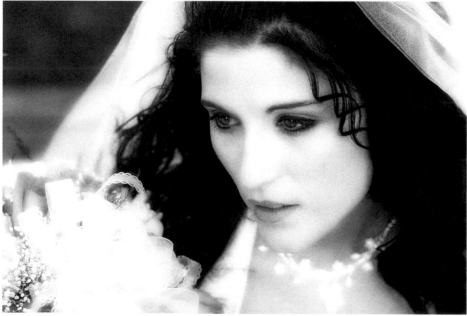

Most brides have a natural, beautiful glow. In Photoshop, you can enhance that glow for an artistic image.

The secret is to use the Diffuse Glow filter.

**Step 1:** Open an image and go to Mode > Grayscale. Converting an image to a grayscale image is not the best way to make a black-and-white image, but it's okay for this technique.

**Step 2:** Go to Filter > Distort > Diffuse Glow.

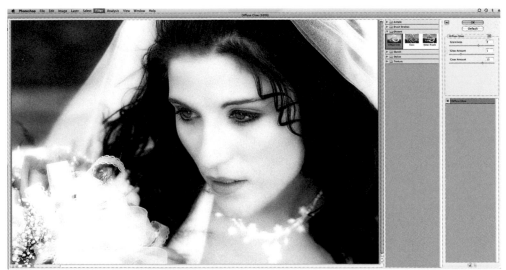

**Step 3:** In the Diffuse Glow dialog, play around with the sliders to create your customized diffuse-glow effect.

**Step 4:** Click OK.

In just a few minutes, you transformed a straight image into a wonderful image that glows!

# Create the Disequilibrium Effect

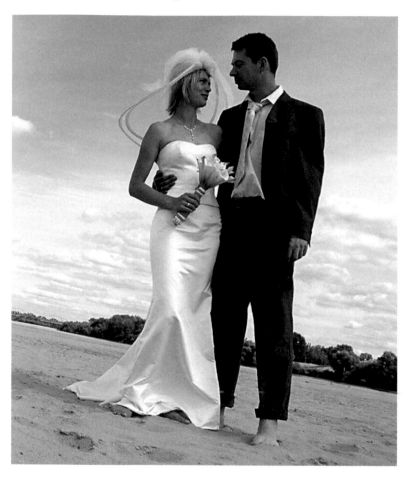

You probably noticed that some of Davide's photographs have a titled horizon line, as in this image. That's done on purpose to add more interest to a picture. It's called the *disequilibrium effect*, because it sets the viewer's sense of equilibrium slightly off balance.

Wedding photographers are not the only shooters who use this effect. Fashion and beauty photographers use it, too, in order to create more artistic images.

Here is how you can mimic the technique.

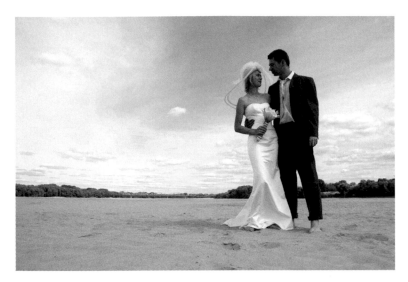

**Step 1:** The first step to creating this effect actually takes place during your photo session... if you know then that you want to create this effect.

Basically, you need to compose your picture with plenty of "dead space" around the subject, because you'll crop out part of the image area to execute this technique. In the cropping process, you don't want to eliminate an important part of the subject.

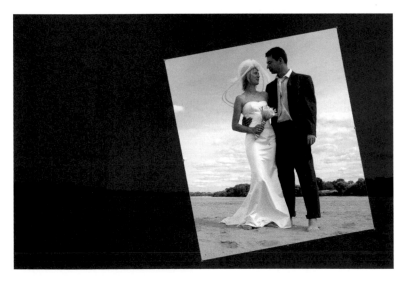

**Step 2:** Go to the Tool bar and select the Crop tool. Crop the entire image but don't press Return. Rather, move your cursor outside of the image area. When you do, you get a double-sided arrow. Swiveling that arrow tilts the image.

When you are pleased with the effect, press Return and enjoy this dynamic effect.

# Create Dramatic Shadows in the Studio

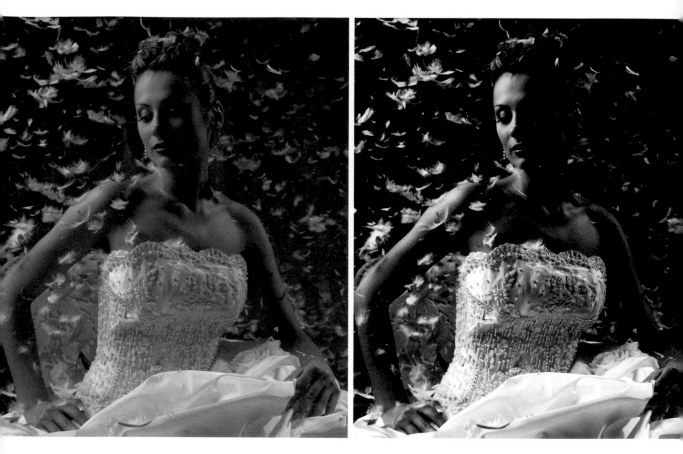

Light illuminates; shadows define. That's one of my favorite photographic sayings.

Shadows can make or break a picture. They can also turn a flat shot into a much more dramatic image.

Oh, you have shadow issues in your photographs? No problem to fix them in Photoshop when you use a few adjustments and change the blending mode.

**Step 1:** Duplicate your layer by going to Layer > Duplicate Layer or by pressing Command/ J.

**Step 2:** With the top layer activated, go to Image > Adjustment > Hue/ Saturation. Completely de-saturate the image by moving the triangle on the Saturation slider all the way to the left.

**Step 3:** On the same layer, go to Image > Adjustment > Brightness/ Contrast. Boost the contrast all the way up by moving the triangle on the slider as far as possible to the right.

**Step 4:** In the Layers panel, change the blending mode to Overlay.

**Step 5:** Watch the expression on your client's face when (s)he sees this dramatically lit shot.

# Soften Skin in an Instant

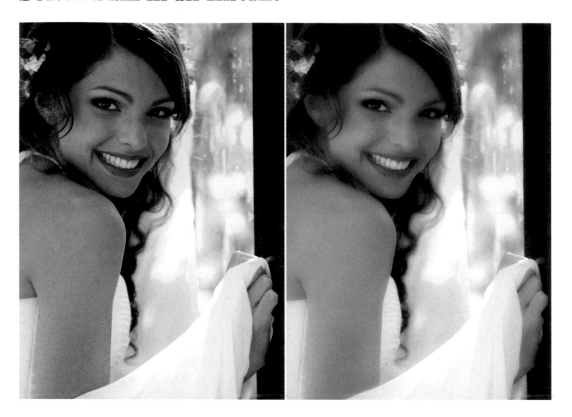

No doubt that this bride has beautiful skin. But you don't encounter that on every shoot. Here's a quick and easy method for softening skin while retaining details in a subject's eyes.

This is one of my favorite image-enhancement techniques—made possible by the magic of Photoshop.

**Step 1:** Open a file and duplicate it by going to Layer > Duplicate Layer, or by pressing Command/ J.

**Step 2:** Change the Blending mode to Overlay.

**Step 3:** Go to Filter > Other > High Pass.

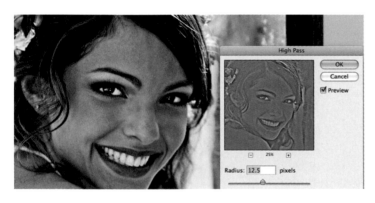

**Step 4:** Don't panic. Your image will look a bit wacky after you apply this filter.

Experiment with the Radius slider. The higher the resolution, the higher you should set your radius.

After you click OK, press Command/ I to invert the image. This is VERY important. After you press Command/ I, your image should have the desired soft touch. If it looks too soft, reduce the Opacity of the layer in the Layers panel.

**Step 5:** Add a Layer mask by clicking on the Add Layer Mask icon at the bottom of the Layers panel.

With black selected as your foreground color and with a soft-edge brush selected—set to Opacity around 25%—carefully mask out the soft areas over the eyes and mouth.

That's it! Don't forget to press Command/ I.

# Blur the Background

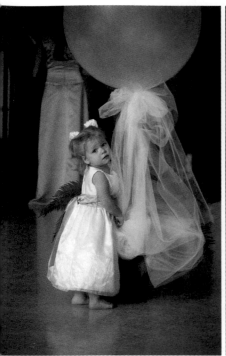 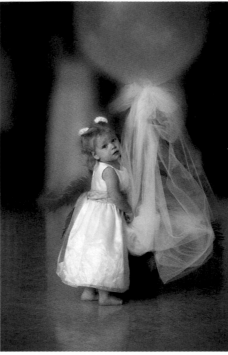 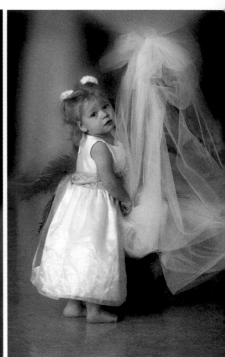

The background can enhance or detract from the main subject. At weddings, backgrounds are not always the greatest.

Enhancing the background is no problem in Photoshop, especially when you use the Gaussian Blur filter.

**Step 1:** Go to Filter > Convert for Smart Filters (which allows you to use a filter like an adjustment layer with a layer mask). Then select Blur > Gaussian Blur.

**Step 2:** Blur the image until you are pleased with the background blur. Don't be concerned with the blurred main subject.

**Step 3:** In the Layers panel, click on the Layer mask and, with black selected as the foreground color and with a soft-edge brush selected, mask out (paint over) the main subject.

For a smooth transition between the sharp and blurred areas of your image, reduce the Opacity (on the Menu bar at the top of your monitor) as you move back and forth from one area to the other. Start with the Opacity set at 100% when painting over the main subject, and end with the Opacity set at 10% or even 5%.

Of course, cropping a picture can help draw more attention to the main subject, as can shooting tight and using a telephoto lens set at a wide aperture for shallow depth-of-field.

# Dress Up your Web Site with Drop Shadows

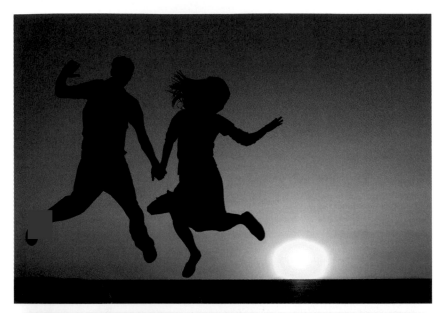

Your web site is your calling card—your portfolio and best
sales tool. Dress up your images and your site by adding cool
drop shadows to your images.

Drop shadows are easy to create when you use Layer Styles.

**Step 1:** Open an image file and go to Image > Canvas Size. Add an inch or two to the size of your image. The size really does not matter at this point.

**Step 2:** Go to Layer > Layer Style > Drop Shadow. Move the slider to the left to create your own custom drop shadow. Click OK. Your image will appear to be floating on the page!

# Create a Thank You e-Card Template

Want to do a nice favor for your clients ... or maybe make a few extra bucks? Create a nice thank you e-card for them.

Adding text to an image is easy in Photoshop.

**Step 1:** Open an image and select the Type tool in the Tool bar.

**Step 2:** Select the color of your text by clicking on the Set Foreground Color icon at the bottom of the Tool bar.

**Step 3:** In the Menu bar at the top of your monitor, select the typeface. Here, I chose Apple Chancery.

**Step 4:** Also on the Menu bar, choose the size of your type.

**Step 5:** Type your message.

You can use different typefaces set at different sizes and in different colors (as I did here) for different message lines in your file. Just hit Return after each line, and then select the Type tool again for each new line. You can also place and reposition each line by clicking on the individual type layer and using the Move tool.

# Create the Best Black-and-White Image Ever

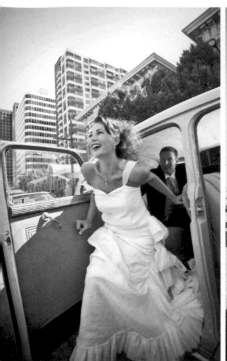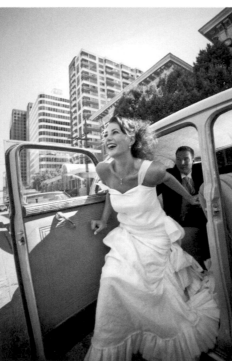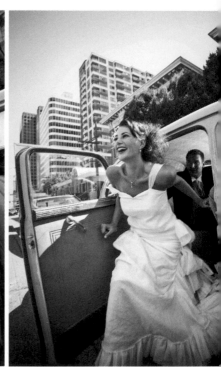

Black-and-white images tend to look a bit more creative and artistic than color images. That's why brides and grooms love 'em. Here is an easy way to have the most control over all the tones in a file.

Create a Black & White adjustment layer.

**Step 1:** Open an image file. Go to Layer > New Adjustment Layer > Black & White.

**Step 2:** In the Layer panel under Adjustments, you'll see your tone controls along with a hand/ double-arrow icon. Click that icon.

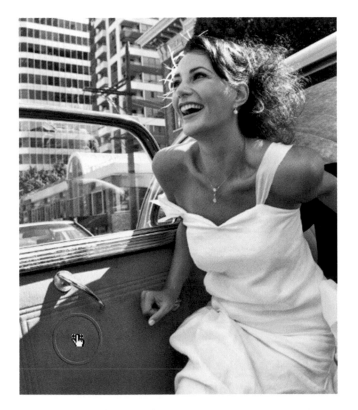

**Step 3:** Move your cursor (now the hand/ double-arrow icon) into your image and place it on a tone you want to change. Move your cursor from left to right to change that tone.

This is a totally awesome control, because you make your adjustments live while working on the image—not in the Adjustments panel.

# Create a Beautiful Vignette

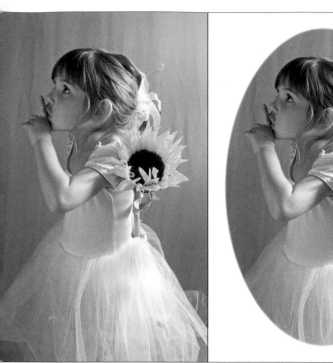 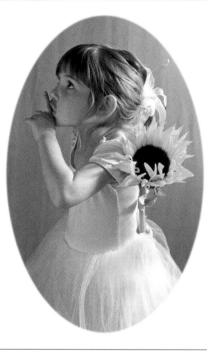 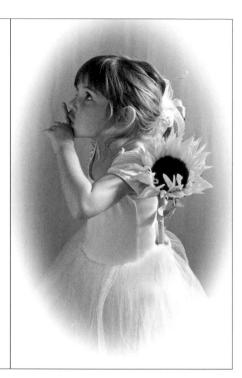

Since the early days of wedding (and portrait) photography, photographers have been using vignettes to create more artistic and creative images.

You can do this, too, by simply using Photoshop Vignette Action.

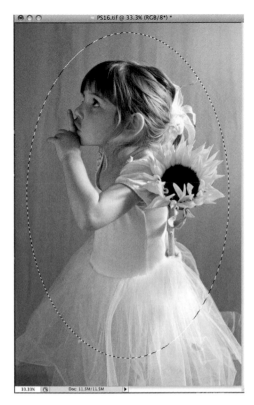

**Step 1:** Open an image. Using the Elliptical Marquee tool on the Tool bar, draw an oval around the main subject.

**Step 2:** Open Actions by going to Window Actions. Click on Vignette (selection).

When you click on Vignette (selection), you get a pop-up window in which you should choose the Feather Radius. A low setting results in a hard-edge vignette, as illustrated by the middle image. A high setting results in a much softer-edge vignette, as illustrated by the image on the right.

As a starting point, use a Feather Radius of 100 when working on an image with a resolution of 300 PPI.

Click OK. Voilá!

# Add a Sense of Motion to a Still Image

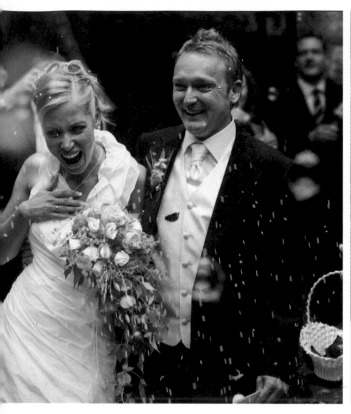 

How cool! Thanks to Photoshop, we can add a sense of motion to a still image, which adds more life and more excitement to your photographs.

The Radial Blur filter is the secret to creating this effect.

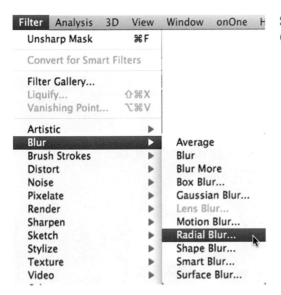

**Step 1:** Open an image and go to Filter > Convert to Smart Filter.

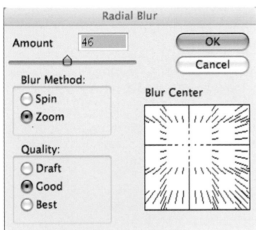

**Step 2:** Go to Filter > Blur > Radial Blur > Zoom. Play around with the amount. (I usually don't go above 50.)

You can place the center of the blur anywhere in the image by clicking in the Blur Center window and moving the center of the blur.

Click OK.

**Step 3:** In the Layers panel, click on the Layer mask. Set black as the foreground color in the Tool bar and choose a soft-edge brush.

Start masking out the blur over the subjects with the Opacity (an option on the Menu bar at the top of your monitor) set at 100%. As you move outward from the main subjects, gradually reduce the Opacity. Your goal is to make a smooth transition between the blurred and sharp areas of the image.

In the screen shot, the black areas represent the Opacity set at 100 percent, while the gray areas show where Opacity is reduced.

# PhotoTools and PhotoFrame Totally Rock

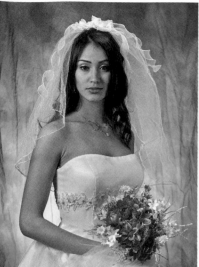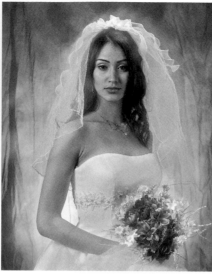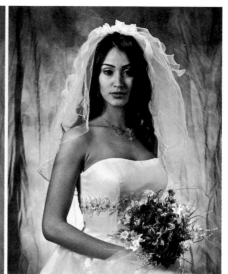

How would you like to apply sophisticated effects to your images ... the kind of effects top wedding photographers use? Well, most of them typically require a bizillion enhancements, tweaks and adjustment layers—not to mention years of digital darkroom experience.

But not with a Photoshop plug-in! Plug-ins are available via the Internet and on CDs, and they dramatically expand the capability of Photoshop (and other plug-in compatible programs, such as Lightroom and Aperture). After downloading, they are usually placed in your plug-in folder automatically.

Dozens of these expert effects are available at the click of a mouse with Photoshop plug-ins. Those that I use most often are PhotoTools and PhotoFrame. Both are available through onOne Software (www.ononesoftware.com).

Above you see, from left to right, my original image, the effect of applying onOne's Light Ray and the effect of applying onOne's 30's Noire.

Here's an idea for playing with PhotoTools: After you apply an effect, try fading it (an option in the main window). Want even more creative options? Apply more than one effect to a photograph.

 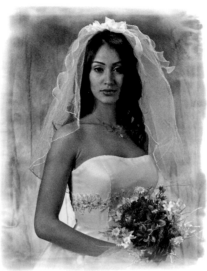 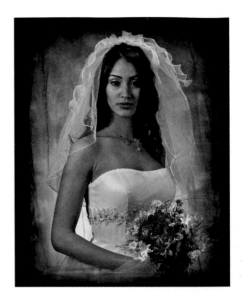

OnOne PhotoFrame offers limitless custom digital frames ... in all shapes, sizes, colors, textures and forms. Like in PhotoTools, you have total control of the frame you select and can place it around your image how and where you want.

Here you see, from left to right, the original image, the effect of applying Emulsion frame (with a white background) and the effect of applying the same Emulsion frame (with a black background).

Black and white, by the way, are only two colors from which to choose for the background. You can literally choose any color in the rainbow to complement your subject and to make your photographs stand out from your competition.

Want more creative plug-in ideas? Check out Plug-in Experience (www.pluginexperience.com). I started this web site to share the latest and greatest plug-in info and to showcase the artistic plug-in work of some of today's top photographers. You'll find some nice discounts on plug-ins here, too.

# Color Efex Pro Plug-In

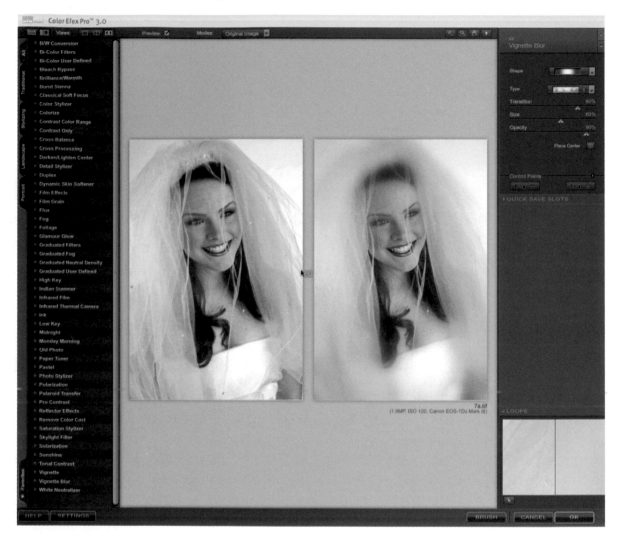

Nik Software's Color Efex Pro (www.niksoftware.com) is another of my favorite plug-ins. The main window is shown above; it's where you take creative control of your image.

To apply an effect, first click it from the panel on the left. Then, for total creative control, adjust and fine-tune the effect to your own liking.

Here you see, from left to right, the original image, the image with the Vignette Blur effect applied, and the image with the Midnight filter applied.

You also have viewing options, including side-by-side, which you select at the top of the panel.

# Index